IMAGES
of America

SIMPSONVILLE

IMAGES
of America

SIMPSONVILLE

Mrs. Mihalic,

*Thank you for years
of love and support!*

Andrew M. Staton

ARCADIA
PUBLISHING

Published by Arcadia Publishing
Charleston, South Carolina

Printed in the United States of America

Library of Congress Control Number: 2016930433

For all general information, please contact Arcadia Publishing:
Telephone 843-853-2070
Fax 843-853-0044
E-mail sales@arcadiapublishing.com
For customer service and orders:
Toll-Free 1-888-313-2665

Visit us on the Internet at www.arcadiapublishing.com

To my mom, Christy Staton, for without her wisdom and guidance, this project would not have been possible.

CONTENTS

Acknowledgments 6

Introduction 7

1. Early History 9

2. Woodside Mill 17

3. Education 29

4. Churches and Cemeteries 47

5. Buildings and Businesses 61

6. People and Families 79

7. Historic Homes 97

8. Public Safety and Services 113

9. Recent History 121

ACKNOWLEDGMENTS

This book would not have been possible without the help and support of the Simpsonville community as well as my friends and family—most of all my parents, Glenn and Christy Staton, my grandparents Ron and Dayna Hill, and my love and best friend, Meagan Pickens, who all helped tremendously along the way.

For providing me with the images and materials found in this book, credit goes to Darin Bridgeman, Mike Burton, Steve Cox, Robbie Davis, Beth and Gary Fann, Mike Folk, Linda Fowler, Cecil Hare, Martha Harrison, Phil Hathcox, Pat Henderson, Dayna Hill, Carol Leake, Geneva Lawrence, Phyllis Long, Caroline Mahaffey, Doug Mayfield, Betty Putman, Christy Staton, Pam and Brown Garrett, Butch and Diane Kirven, Dennis and Patty Waldrop, Bryan Skipper with Hillcrest High School, Spiro Eliopoulos with Coach House Restaurant, Allison McGarity and Jennifer Richardson with the Simpsonville Area Chamber of Commerce, Rulinda Price and others with the Greenville County Library System, Steve Smith and Gretchen Maultsby with Spartanburg County Public Libraries, Lucy Quinn with the Greenville County Historical Society, Greg McKee with the YMCA, and the Greenville County School District. To avoid repetition and save space, the Simpsonville Genealogical Research Room is not individually mentioned in the captions of this book. However, as I am its executive director, I wish to credit the research room for helping me to find the resources and make the connections that made this book possible.

In addition, thanks go to the following friends and neighbors for their constant help and support: Michael Bacaro, Jenny Clark, Dot Cooley, Stephanie Cox, Rory Curtis, Beth Fann, Al Futrell, Crystal Greenway, Becky Henderson, Amanda Hodgson, and Dave and Becky Knapp.

Finally, a thank-you to the wonderful staff at Arcadia Publishing, including Sophia Mathelier and Sarah Gottlieb, for helping to make this book a reality.

INTRODUCTION

Before beginning Images of America: *Simpsonville*, it is necessary to include a disclaimer. To take the history of Simpsonville, South Carolina, which spans over 200 years, and compile it into a single book is a task beyond possibility. Behind each picture, caption, and introduction in this book is an entire story to be told—another book that could be written solely about that one subject. Additionally, since this is a photographic history, there may be stories that are untold or prominent events that are unseen, due to an inability to gather relevant pictures in time for publication. To put it simply, while this book is intended to tell the story of Simpsonville, it should be read as a collection of stories in its own right. If a certain person or place is omitted, consider it not a failure of the book, but as a suggestion for a second volume. The aim of this book is not to complete the story, but rather to begin it.

When discussing the long and multifaceted history of any city such as Simpsonville, there are always clear phases in its development. Marked by a shift in leadership, a population growth, the arrival of a certain industry, or some other change, these phases and the events surrounding them are what give a city its unique identity. For Simpsonville, this is no different, with certain years and milestones rushing to mind when considering what triggered a change in the local environment. To present these milestones and explain the history of Simpsonville in the most comprehensible way possible, it seems easiest to present a chronological narrative of the city. However, it would be difficult to weave several of the stories that are presented in this book together chronologically; in addition, historic images only exist for certain points in time. The result is the organization found in this book: chronological chapters at the beginning and end that represent the earliest and most recent histories of the area, along with seven internal chapters organized by topic, concentrating on the period from 1900 to 1975.

The chapters on early history and recent history have a surprising amount of similarities regarding the development of the area. In each instance, it can be seen that one seemingly small event, such as the development of the railroad or the opening of a new factory, can be the first in a series of steps that brought Simpsonville into another phase of growth and change. In Simpsonville's formative years in the 19th century, the arrival of Peter Simpson and other pioneers set the area down a path to forming a town; in just 60 years, the town received its official charter. A similar pattern is seen with Simpsonville's recent history, as the opening of Cryovac and development of neighborhoods by Ralph Hendricks (and others) set Simpsonville down a path of unprecedented growth and commercial prosperity.

In the inner chapters, the topics that were chosen combine to reveal the backbone of Simpsonville's growth, culture, and community. These topics cover elements from all aspects of the average Simpsonville resident's life, essentially consisting of work, school, religion, commerce, security, and residence. First and foremost, unique to the history of Simpsonville is the heavy and pioneering emphasis placed on education, which organized prominent figures from across the area to ensure a strong and formative education for all children. No expenses were spared in the construction

of viable schools, and Simpsonville ultimately became a pioneer of education by offering grades and programs not offered anywhere else in the county. Regarding the residency of Simpsonville citizens, the chapter on historic homes illustrates the most significant houses in the area, both architecturally and historically. The chapter on Woodside Mill provides insight into the lives of poor mill workers. The most notable people and influential families who resided in these homes are also highlighted in a chapter discussing such pioneering families as the Kilgores and Greshams; this chapter also covers influential figures such as the 17 mayors who have served the city.

The largest chapter is that concerning the buildings and businesses that have arguably shaped the development of the area more than anything else. From small family-owned businesses to the commercial success of the Fairview Road corridor, Simpsonville's economic prosperity has been fueled by its businesses since the very beginning. The buildings that the businesses and residences are housed in are also interesting, and significant from an architectural standpoint. This also applies to the town's magnificent church buildings, ranging in style from Greek Revival to modern and postmodern constructions. Simpsonville's churches are among the most culturally significant aspects of the town's rich history, providing a safe haven for residents to worship and express their beliefs. Finally, the history of Simpsonville is rounded out with a discussion about area government, public services, and public safety that have been instrumental in keeping Simpsonville a vibrant and safe place to live for over a century.

With all of its stories to tell, many of which are addressed here, Simpsonville, South Carolina, has long deserved a book about its history, and it is my distinct honor to finally be able to present one. Please enjoy it.

One

EARLY HISTORY

The first phase in the development of Simpsonville began with the settlement of the Austin family in the Gilder Creek area in 1774. Prior to this, the area was part of the territory of the Cherokee Nation, who referred to it as "Dry Ridge." The Austin family is known to have frequently encountered the Cherokee, with one confrontation resulting in the death of Nathaniel Austin's only daughter. Other families, such as the Kilgores, settled in the area shortly after the Austins, although there was still no central town for several years. By the time Peter Simpson arrived from Laurens County in 1838, a small stop on the road between Greenville and Laurens had been established, known as Plain. Simpson became the postmaster, and although he died in 1847, the wheels had been set in motion to lay out a street grid (this was done by Sidney J. Wilson) and establish a town, which was then renamed in Simpson's honor.

Because of this, Simpson's death in 1847 can be considered the beginning of a second phase in Simpsonville's history—establishing a town. Residents of the area surrounding Simpsonville came together in creating all of the basic elements of a town, such as stores, schools, and churches. While several of these had existed on the periphery of the area, none were previously in the immediate downtown area. Simpsonville High School opened in 1885 in a log schoolhouse on Academy Street, a railroad was laid through town in 1885, and the Simpsonville First Baptist Church was established with a Sunday school in 1888. These new buildings and events put Simpsonville on the map as its incorporation drew closer. Finally, on July 28, 1901, Simpsonville received its charter to officially become a town, with Collier M. Todd appointed as the first mayor.

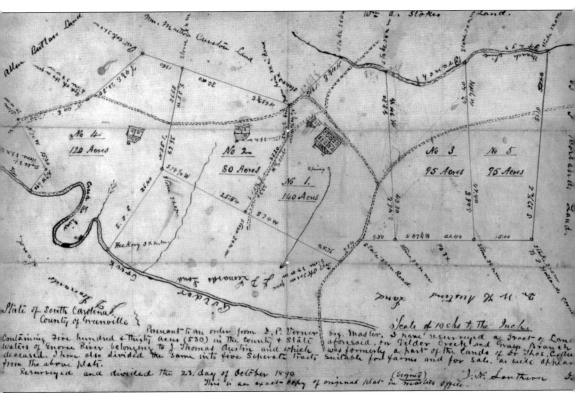

GILDER CREEK PROPERTIES, 1890 MAP. The first family to settle in the Simpsonville area was that of Nathaniel Austin, who received a royal land grant in 1768 and moved to the area in 1774 to establish his family home, which was located one and a half miles inside Cherokee territory. Several skirmishes between white settlers and the Indians are known to have taken place in the early years of the settlement, including one that resulted in the death of Nathaniel Austin's only daughter, Mary. In addition to his daughter, Nathaniel had 10 sons between his two wives, several of whom settled nearby and established plantations of their own. Nathaniel's plantation house, the original Gilder, was a two-story log cabin. This map shows the location along Gilder Creek of Austin's grant. Today, the land has largely been converted into the Holly Tree community and golf course, with Austin's grave located steps away from the 13th hole. (Courtesy of Greg McKee via Al Futrell.)

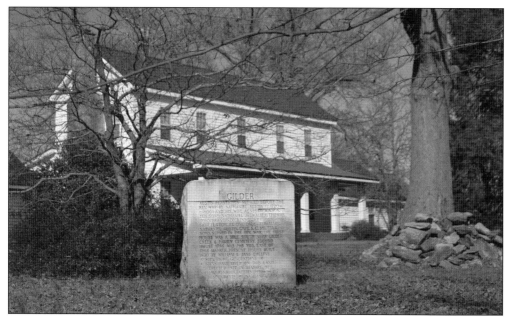

GILDER III. While the first two Gilder plantations no longer stand, the third Gilder house, often referred to as Gilder III, stands in its original location at the corner of Bethel Road and Highway 14. The home was built by Col. William Austin and has remained in the family for eight generations. It is currently owned by Maj. William Renwick Austin II, a veteran of the Vietnam War. (Photograph by Christy Staton.)

OAKLAND PLANTATION. The Oakland Plantation, located along Adams Mill Road, was built by Dr. Thomas Nelson Austin in 1923. Dr. Austin built his medical office adjacent to the house on the property. The house still stands, but the medical office was torn down in 1953, leaving only the foundation visible. The property remained in the family until 2004, when it was sold to the YMCA. (Photograph by Christy Staton.)

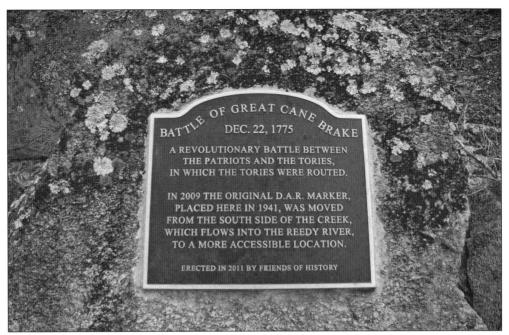

BATTLE OF GREAT CANE BRAKE. On December 22, 1775, in lower Greenville County, a group of Patriot forces led by Col. William Thompson and Col. Richard Richardson attacked a group of Loyalist forces led by Patrick Cunningham. The Patriots outnumbered the Loyalists in both soldiers and ability, and they were ultimately successful in winning the skirmish. This battle, which took place in a heavily wooded area along the Reedy River in the present-day location of the Hopkins Farm, was a crucial moment in the early development of the Simpsonville area. (Both photographs by Christy Staton.)

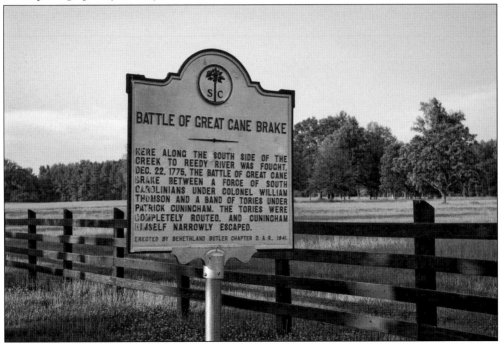

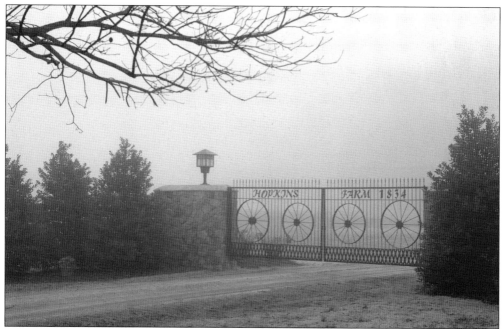

HOPKINS FARM. The Hopkins Family Farm is located southwest of Simpsonville, along Fork Shoals Road. The property was the location of the Battle of Great Cane Brake in 1775, and in 1834 was sold by James Harrison to John Hopkins. Hopkins Farm has remained in the family for several generations since then. (Photograph by Christy Staton.)

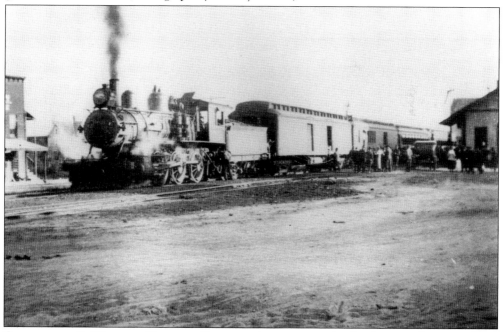

CHARLESTON & WESTERN CAROLINA RAILWAY. A train passes by the depot in Simpsonville in 1917. The railroad came to Simpsonville in 1885, and was later incorporated into the Charleston & Western Carolina Railway (C&WC), marking a turning point for population growth in the area as the town was beginning to develop. (Collection of Eddie Howard, courtesy of Doug Mayfield.)

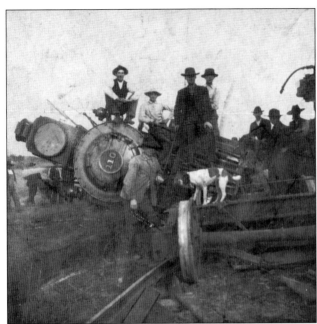

TRAIN WRECK AT KING RESIDENCE. In 1917, a number of spectators—including Pomeroy Brown, seen sitting on the engine—investigate a train wreck located above town at the King family homestead. While this accident is remembered as particularly bad, train wrecks were not uncommon in the Upstate during this period. (Courtesy of Brown and Pam Garrett.)

LIVERY STABLE. In this lithograph by artist James Taylor, the livery stable is depicted in its original location on Maple Street near the present-day intersection with Jones Avenue. Here, visitors from lower parts of the state heading to Greenville could tether their horse and take the train into the city. In the 20th century, the livery stable moved to College Street, where it was operated by Morris Curry. (Copyright Frank Hipps and James Taylor.)

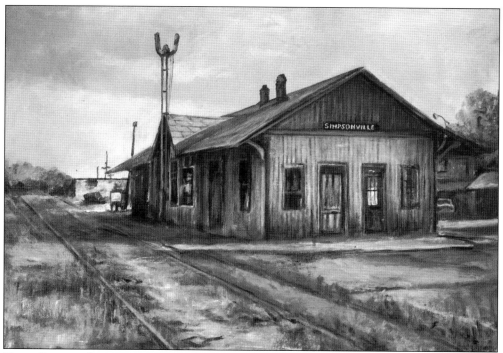

TRAIN DEPOT. The Simpsonville Train Depot was built on South Main Street sometime between 1885 and 1910. Often regarded as being built in a Victorian or Craftsman style, the depot was wooden and stood until 1966, when the building needed too many repairs to save. (Above, lithograph by James Taylor, copyright Frank Hipps; below, courtesy of Cecil Hare via Steve Cox.)

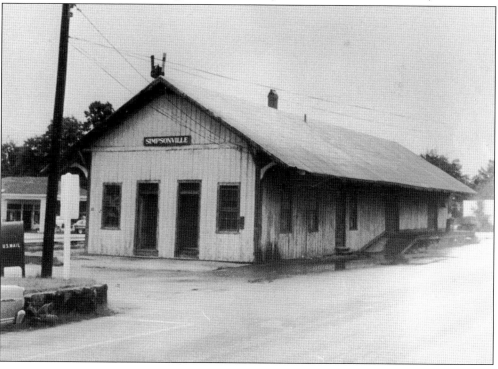

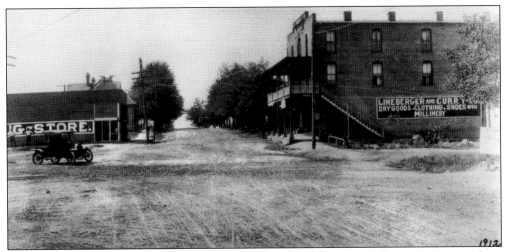

LINEBERGER AND CURRY, 1912. The Curry Hotel and Lineberger and Curry Co. is seen from Main Street in this view looking west down Curtis Street. The owner of the hotel was Simpson Arlington Curry, a member of Hopewell Church who lived to the southwest of the area. Regarding the dry goods store, the likely business partner of Curry was Daniel Edgar Lineberger, who also served as mayor from 1910 to 1912. (Courtesy of Doug Mayfield.)

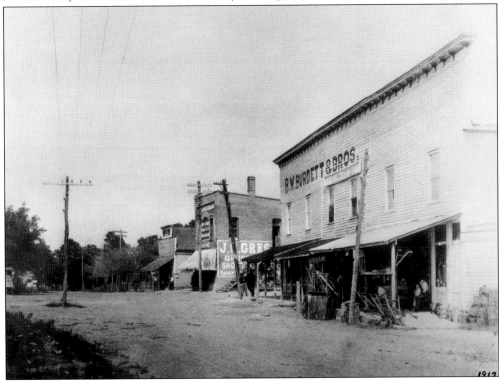

GRESHAM AND BURDETTE, 1912. Simpsonville businesses owned by B.W. Burdette and J.O. Gresham are visible in this view looking north up Main Street at the intersection of Curtis Street. The grocery store apparently owned by Gresham was the first brick building in Simpsonville, while the wooden Burdette Building burned in 1921 and was replaced by a brick structure (pictured on page 63). (Courtesy of Doug Mayfield.)

Two

WOODSIDE MILL

With Simpsonville's formative years in the past and the town having officially received a charter on July 26, 1901, the need for jobs to accommodate a growing population was apparent as the town began to form its own sense of community. At the time, the textile industry was one of the most rapidly expanding and overwhelmingly successful industries in the country, and no area was building textile mills as quickly as the South Carolina Upstate. Piedmont No. 1, the area's first mill, opened in 1873 along the Saluda River in Greenville County, and the concept spread throughout the county, with dozens of mills on the rise. Simpsonville was no exception, and construction commenced on a textile mill in 1907 to satisfy the need for jobs and for textiles.

In 1908, the Simpsonville Mill opened, and in 1911 it became part of the larger Woodside Cotton Mill group that was expanding under the leadership of four Woodside brothers. Constructed along with the mill were four streets of housing for mill workers, a company store and office, a recreation building known as the Forum, and eventually a baseball park and gym. This large complex—known as the mill village or mill hill—fostered a strong and tight-knit community that was unprecedented in Simpsonville. Although quality of life for mill workers was traditionally poor in the way of social status and wealth, the workers formed bonds that allowed for the creation of successful sports teams and community organizations.

For several decades following its opening, Simpsonville's Woodside Mill hosted hundreds of residents and was the biggest employer in the town. While the need for the mill declined in the latter half of the century and it closed its doors in 1980, the building itself has taken on a new life as a complex of condominiums, and the warm memories of the mill village community continue to stay alive.

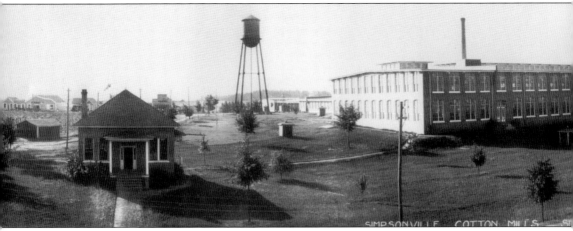

SIMPSONVILLE COTTON MILL, 1908. This panoramic picture of the Simpsonville Cotton Mill dates from its opening year. The left side shows a field where the Temple Baptist Church would later be built, along with the Woodside Mill office, which no longer stands. On the right is the Forum, the recreational building that was demolished in 1947 to construct the Woodside Gym,

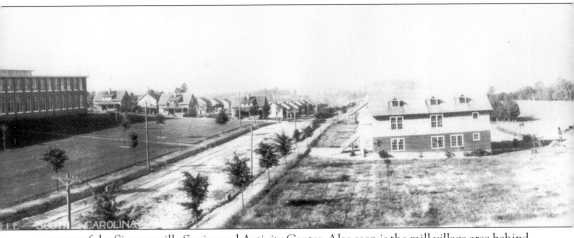

now part of the Simpsonville Senior and Activity Center. Also seen is the mill village area behind the mill—however, the Beattie Street area behind the Forum had not yet been constructed. (Courtesy of Phil Hathcox and the Simpsonville Woodside Mill Reunion Committee.)

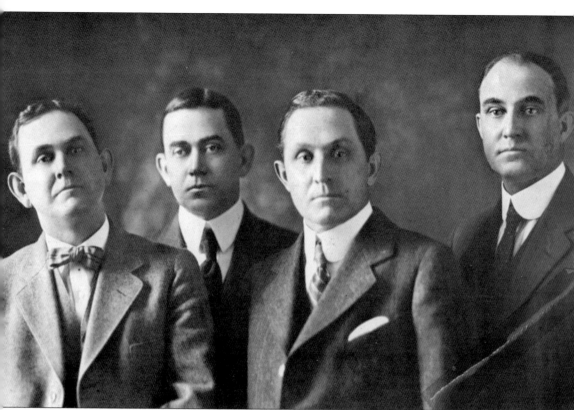

WOODSIDE BROTHERS. The four brothers pictured here—John T., J. David, Robert I., and Edward F. Woodside—founded the Simpsonville Cotton Mill and incorporated it with their other two mills, in Greenville and Fountain Inn. The Woodside family had been a part of local history for several generations, originally emigrating from Ireland and residing in the Fairview Presbyterian Church community. While three of the Woodside brothers did not reside in Simpsonville, Edward was the first president of the mill and lived in the present-day Garden House on South Main Street when the mill first opened in 1908. (Courtesy of the Coxe Collection, Greenville County Historical Society.)

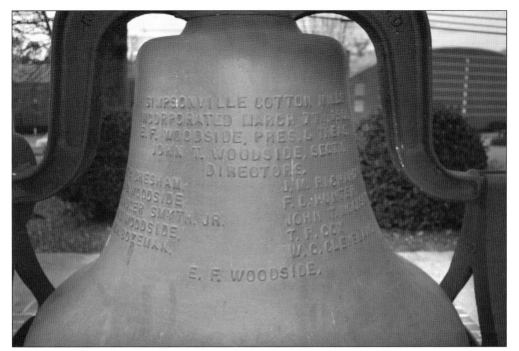

SIMPSONVILLE MILL BELL. The bell that once rang to signal shift changes at the Simpsonville Mill is inscribed with the names of the four Woodside brothers, along with those of W.P. Gresham, J.A. Smyth Jr., W.H. Bozeman, J.M. Richardson, F.D. Hunter, T.F. Cox, and W.C. Cleveland. The bell was moved to a more prominent location in front of the mill during renovations in 2006. (Photograph by Christy Staton.)

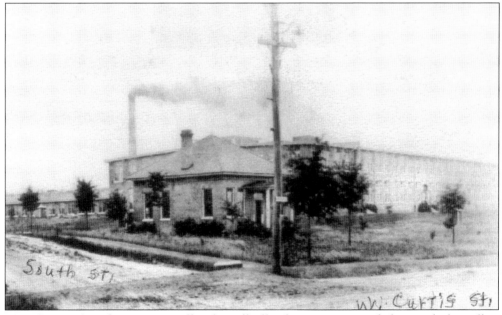

MILL OFFICE. An administrative office for mill officials was constructed along with the mill in 1907. This office sat on the corner of South and Curtis Streets, and was likely demolished around the middle of the 20th century. (Courtesy of Pat Henderson.)

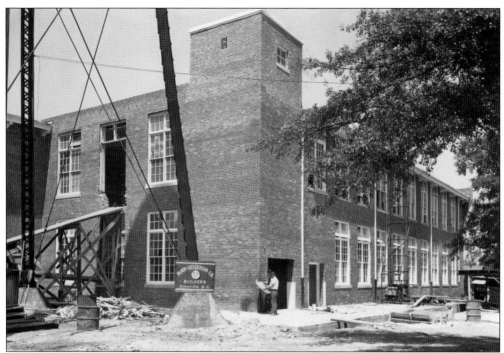

MILL ADDITION, 1947. An addition nears completion on the South Street side of the Simpsonville Woodside Mill in 1947, immediately adjacent to the only surviving water tower. When the structure began its transformation into condominiums in the early 2000s, this addition was removed to create additional space for parking. (Courtesy of the Greenville County Library System.)

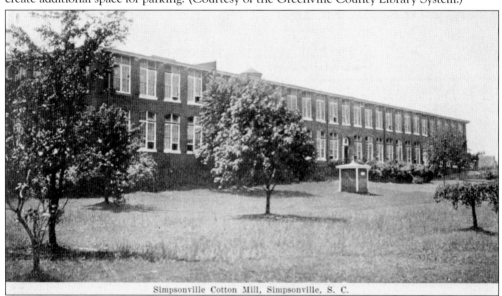

Simpsonville Cotton Mill, Simpsonville, S. C.

WOODSIDE MILL POSTCARD. The Curtis Street facade of Simpsonville's Woodside Mill is seen on this historic postcard. The local group of Woodside Mills most notably consisted of two other locations—in Greenville and Fountain Inn—along with several smaller mills purchased before the eventual merger with Dan River Inc. Greenville's Woodside Mill was the largest textile facility in the world for several years. (Courtesy of Pat Henderson.)

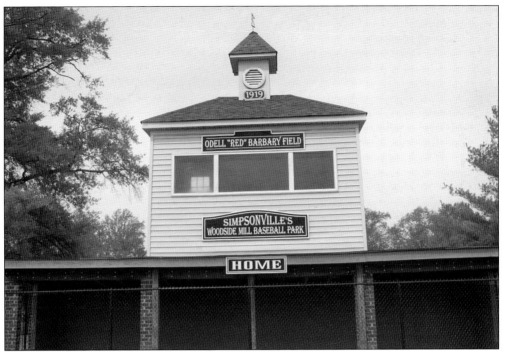

BASEBALL FIELD. As was common with textile mills across the South, a Woodside Mill Baseball Park was constructed in 1919 two blocks from the mill on West Curtis Street. The mill baseball team, known as the Little Yankees, competed in Textile League games against other local mill groups. One Simpsonville player, Red Barbary, went on to eventually play in the major leagues. (Courtesy of Mike Burton.)

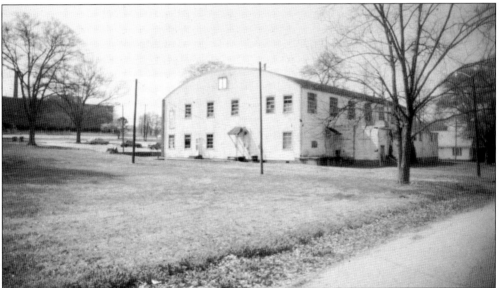

WOODSIDE GYM. Construction began in 1947 on Woodside Gym to replace the former recreational building known as the Forum. Woodside Gym served as a public sports venue for several decades before its physical incorporation into the Simpsonville Senior and Activity Center in 1998 (see page 77). (Courtesy of Geneva Lawrence on behalf of the City of Simpsonville.)

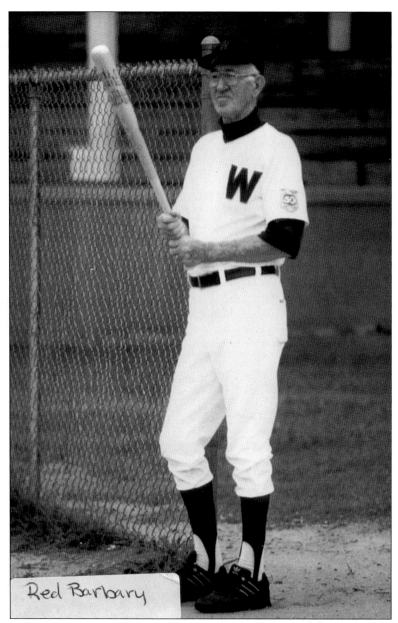

Red Barbary

D.O. "RED" BARBARY. Born in 1920 to Harper and Eula Taylor Barbary, Donald O'Dell "Red" Barbary was raised in the Simpsonville mill village and was a successful lifelong baseball player and manager. In 1939, Barbary signed with the Washington Senators, and in 1943, played one major league at-bat. Although he was typically a catcher, Barbary pitched and won a game for the Charlotte Hornets in 1942 that lasted 22 innings. Locally, Barbary played nine years in the Textile League for Simpsonville, on and off between 1937 and 1954, as well as for Ware Shoals and Southern Bleachery. His legacy included two MVP awards in the 1950s, an induction into the Greater Greenville Baseball Hall of Fame in 1991, and a renaming of Simpsonville Mill's baseball field in his honor. Barbary married Betty Hamby (daughter of the town's first police chief, Charlie Hamby) and had two children. He passed away in 2003 and is buried at Cannon Memorial Park. (Courtesy of the Simpsonville Senior and Activity Center.)

SIMPSONVILLE TEXTILE TEAM, 1940. The 1940 Little Yankees Textile League baseball team, with players bearing an "S" for Simpsonville on their uniforms, lines up for a team photograph. From left to right are Len Goodnough, Cuddy Cox, Champ Hensley, James Chandler, John Stutts, Bob Cox, Lawrence Henderson, Joe Smith, Simp Bagwell, Ralph Barbary, "Red" Barbary, Joel Landers, and Earl Brashier. (Courtesy of Spiro Eliopoulos on behalf of Coach House Restaurant.)

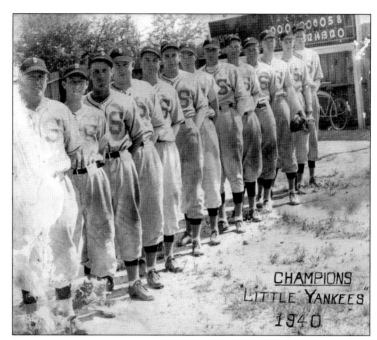

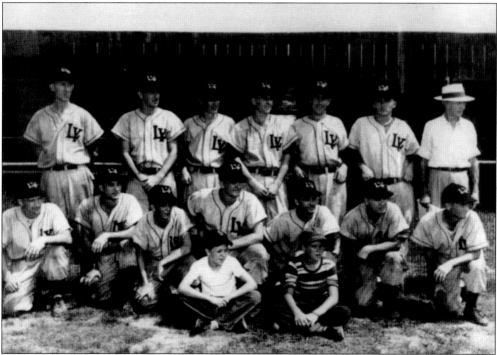

SIMPSONVILLE TEXTILE TEAM, 1950s. A later version of the Simpsonville Little Yankees team gathers for a group photograph in the 1950s. From left to right are (first row) Bruce Marler and Billy Brooks; (second row) Jack Long, Bo Gregory, Dick Goodnough, Don Jones, Jack Goodnough, Roger Cannady, and Cuddy Cox; (third row) "Red" Barbary, Darrell Medlock, Gary Henderson, Ed Davis, John Chalmers, Wayne Davis, and Oscar Haynes. (Courtesy of Spiro Eliopoulos on behalf of Coach House Restaurant.)

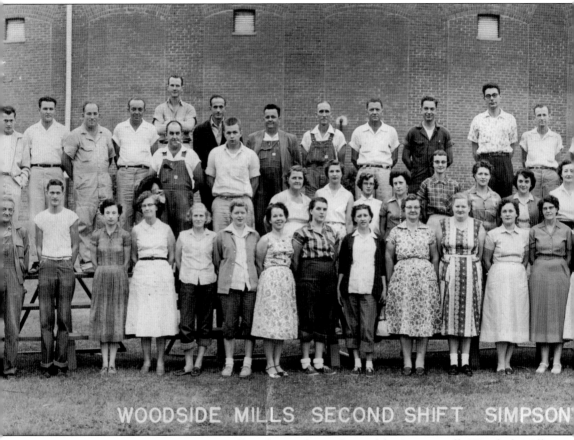

WOODSIDE MILLS SECOND SHIFT SIMPSON

SECOND-SHIFT EMPLOYEES, 1956. Mill workers gather in front of the Simpsonville Woodside Mill for a group photograph. The second shift was typically known as the least desirable shift, as it took employees away from their families for evening meals and after-school time. For many years, employees of the mill were required to live in the associated mill village—or on the "hill"—so

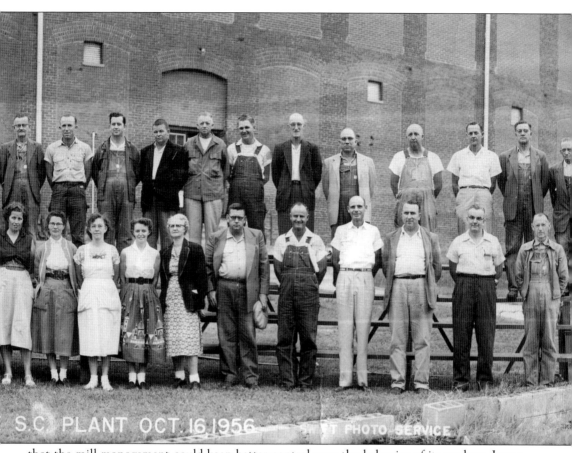

S.C. PLANT OCT. 16 1956 — ST PHOTO SERVICE

that the mill management could keep better control over the behavior of its workers. James Robert Owens stands fifth from right in the first row. (Courtesy of Martha Owens Harrison and Betty Owens Putman.)

MILL AREA, 1950s. This aerial photograph of the mill from the 1950s shows all three of the water towers that at one point stood in Simpsonville. The most distant of the towers was directly behind the downtown businesses on South Main Street, and the tower on the left was along Green Street between the mill and mill village. The center tower, along South Street, still stands. (Courtesy of Pat Henderson.)

WOODSIDE–DAN RIVER. In 1956, the entire chain of Woodside Mills was purchased by Dan River Inc., becoming part of its Greenville Group in 1976. The Simpsonville Mill closed four years later, in 1980, and sat empty for over 20 years until it was transformed into condominiums in the 21st century. (Courtesy of the Greenville County Library System.)

Three

EDUCATION

If the story of Simpsonville were to be remembered for only one quality, it would likely be the strength and prominence of education throughout the town's history. In 1885, the year many consider to be the date of the founding of the town, Simpsonville High School opened its doors for the first time in a simple log schoolhouse on Academy Street. In 1907, a new brick building was constructed across from Simpsonville's short-lived music college on College Street to house both the high school and elementary school. In 1915, the high school became the first in the county to add the 11th grade, and another building was added in 1920 to provide more room. In the 1930s, the newly created Works Progress Administration (WPA) helped to construct two new school buildings, one on Academy Street and one to replace the 1907 building on College Street. These new buildings, which still stand, were utilized until 2001 by Simpsonville Elementary School. Simpsonville High School, however, closed in 1958, with students from Fountain Inn and Mauldin combined in the new Hillcrest High School.

In addition to the facilities for white residents, a number of local schools existed for African Americans over the years. The original Simpsonville High School building—the 1885 log schoolhouse—was not demolished, but rather moved to a location near Cedar Grove Baptist Church to become the first local school for African Americans. The Rosenwald School program added a few black grammar schools to the area, serving several decades as the main facilities for African American students. Bryson High School opened in 1954 on land originally owned by the Meadors family, but desegregation in 1970 merged the school with Hillcrest High School.

Other schools in the area, most of which were rural grammar schools whose students fed into Simpsonville High School, included Pliney, Oaklawn, Stewart's Academy, Fairview, Hopewell, Oak Grove, Bethel, Jonesville, and Hillside. These schools were closed by the 1950s and consolidated into larger schools. Elementary schools now serving the area include Plain, Bryson, Bethel, Simpsonville, Greenbrier, Bell's Crossing, and Rudolph Gordon, in addition to the middle schools of Hillcrest, Bryson, Fisher, and Ralph Chandler.

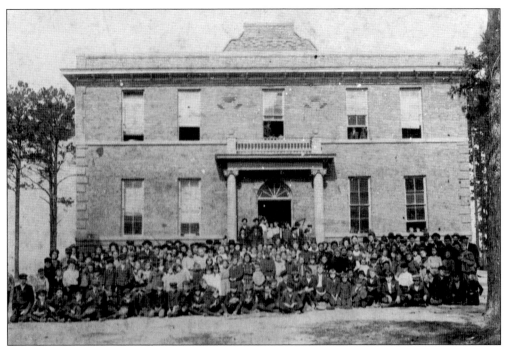

FIRST BRICK SCHOOL. A group of students gathers in front of the first brick school building in Simpsonville. The first high school opened in 1885, and this structure was built after two wooden school buildings that had been used previously. When the building was replaced in 1907, it was moved and served as the school for African American students. (Courtesy of Doug Mayfield.)

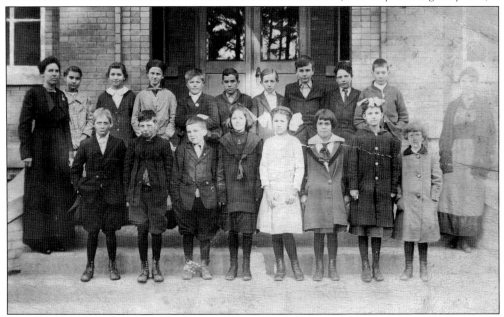

SIMPSONVILLE CLASS PICTURE. A group of young Simpsonville students gathers for a portrait in front of the original Simpsonville Elementary and High School building. Willie Elizabeth Cox stands in the first row, third from right; the rest of the students are unidentified. (Courtesy of Darin Bridgeman.)

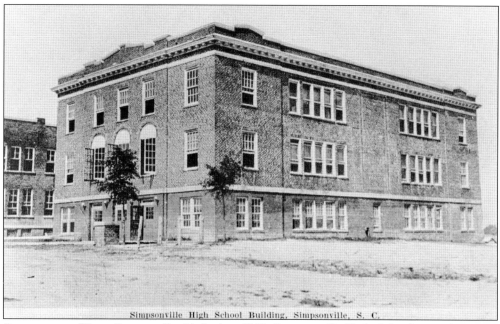

Simpsonville High School Building, Simpsonville, S. C.

SIMPSONVILLE HIGH SCHOOL. Established in 1885, Simpsonville High School started out in a small wood-frame building near the corner of Academy and College Streets. A three-story brick building was constructed on the northwest corner of this intersection around 1920, with a gym on the bottom floor, classrooms on the second floor, and an auditorium/cafeteria on the third floor. The first in the county to teach through the 11th grade, the high school combined students from several elementary schools—Pliney, Stewart's Academy, Oak Grove, Hopewell, Jonesville, Bethel, Fairview, Hillside, and Simpsonville. The high school closed in 1957 in a merger that formed Hillcrest High School with additional students from Mauldin and Fountain Inn. (Above, courtesy of Cecil Hare via Steve Cox; below, courtesy of the Greenville County School District.)

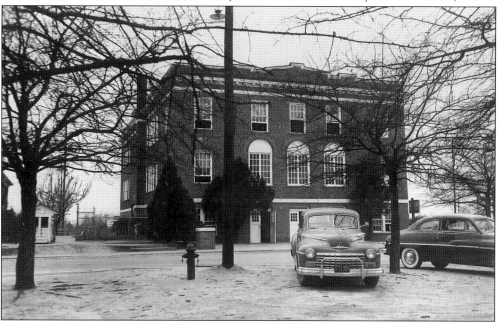

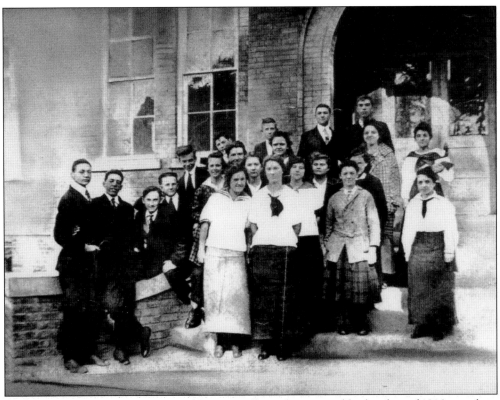

SCHOOL GROUP, C. 1916. A group of Simpsonville students, possibly the class of 1916, stands in front of the former High School and Elementary School building. Among the students are future furniture store owner Robert Jones; his future wife, Essie Mae Howard; Jeff R. Richardson, son of Dr. L.L. Richardson; his future wife, Maude Blakely; and her sister Helen Blakely. (Courtesy of Caroline Richardson Mahaffey.)

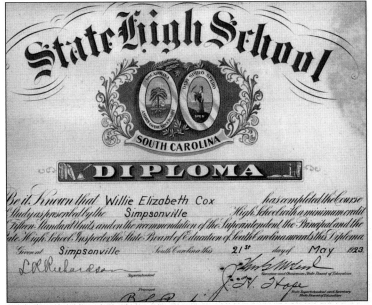

SIMPSONVILLE HIGH SCHOOL DIPLOMA, 1923. South Carolina high school diplomas in the 1920s were largely identical, with the name of each school being written in. This diploma was earned by Willie Elizabeth Cox in 1923 and notably bears the signature of school superintendent L.R. Richardson. (Courtesy of Darin Bridgeman.)

GRADUATION ANNOUNCEMENT AND INVITATION, 1923.
Graduates of Simpsonville High School in 1923 had their commencement ceremony at 8:00 on a Monday night, in the auditorium on the top floor of the high school. The class motto was *Qui vivra verra*, a French phrase often translated as "Live and Learn," the colors were pink and cream, and the flowers were pink and cream rosebuds. Thirty-two men and women received degrees. (Both, courtesy of Darin Bridgeman.)

CLASS OF
1923

Class of

Nineteen Hundred Twenty-three

Simpsonville High School

requests the honor of your presence at the

Commencement Exercises

Monday Night, May Twenty-first

School Auditorium

at Eight- o'clock

MOTTO: "Qui vivra verra."

COLORS: Pink and Cream.

FLOWERS: Pink and Cream Rosebuds.

CLASS ROLL

AGNES GWENDOLYN WHITE, President
ROSE McKINNEY, Vice President
ALVIN WHITE, Secretary and Treasurer
HUGH THOMAS McDANIEL
LOIS IRENE JONES
FARREL ELLIS CASON
PLINY EDWIN MOON
THOMAS C. STEWART
WILLIE ELIZABETH COX
INA OETJEN CURRY
NINA ARLING CURRY
KATE THACKSTON
VERA CHAPMAN
HETTIE MAE GARRETT
ALVIS BROOKS
CLETA A. CHILES
LOLA N. ALEXANDER
AGNES JONES
SARAH ELIZABETH STEWART
ANNIE TALLEY
SARA ADELINE GRIFFIN
LUCY CAROLINE BURDETTE
B. EVERETTE BURDETTE
ESTELLE McKINNEY
FRANCES MARIE HUFF
ETTA SULLIVAN
ELIZABETH WOODSIDE
PERNIE FRANCES COOPER
SARA ALICE PEDEN
NETTIE D. THOMPSON
J. EARLE SIMS
FRANCES MARIE BARKER

SIMPSONVILLE ELEMENTARY SCHOOL (ACADEMY STREET). Constructed in the 1930s through the WPA, the Simpsonville Elementary School building contains six classrooms with an auditorium and gymnasium that were also used by Simpsonville High School. The school closed in 2001, and the building was briefly utilized by Plain Elementary School before being purchased by the city for use as an arts and cultural center. (Courtesy of the Greenville County School District.)

COLLEGE STREET SCHOOLS. Simpsonville Elementary School and Simpsonville High School are pictured together in the 1950s. The building on the left was the second structure built by the WPA in 1939, and replaced the 1907 building that once housed both the high school and elementary school. (Courtesy of the Greenville County School District.)

34

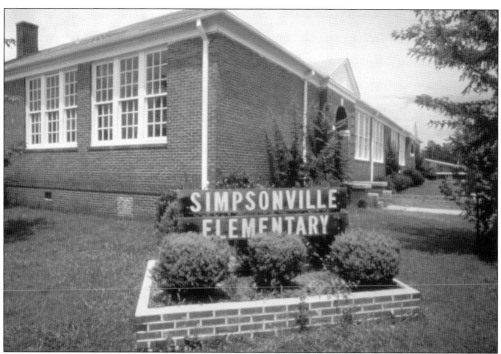

SIMPSONVILLE ELEMENTARY SCHOOL. The main classroom building of Simpsonville Elementary School was used by students until 2001. After Simpsonville High School closed in 1957, the building on College Street was torn down and an expansion of the elementary school built in its place, including a cafeteria, library, and additional classrooms. (Courtesy of the Greenville County School District.)

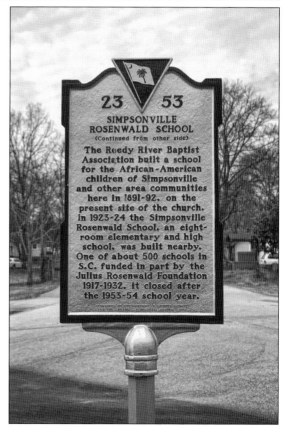

ROSENWALD SCHOOL. The Rosenwald School program for African Americans, started by businessman Julius Rosenwald and consisting of over 5,000 schools across the country, had a large presence in lower Greenville County. Several existed in Simpsonville and Fountain Inn, including one at Cedar Grove Baptist Church. The headquarters, known as St. Albans Training School, was located on Fork Shoals Road. (Photograph by Christy Staton.)

MUSIC COLLEGE AND AGRICULTURAL BUILDING. Second-grade students of Simpsonville Elementary School sit on the steps of the former music college building in 1922. The building was erected on the corner of Church and College Streets in 1911, and housed the music college that opened in Simpsonville the same year. The music college closed after about 10 years, and music instruction was incorporated into the high school curriculum, leaving the building to be used by Simpsonville Elementary School. Later, the building was moved to the opposite corner of the same block before being relocated again behind the 1939 school building on Academy Street, where it housed the Simpsonville High School agricultural education program. The high school closed in 1957 and the building was then demolished. (Above, courtesy of Pat Henderson; below, courtesy of the Greenville County School District.)

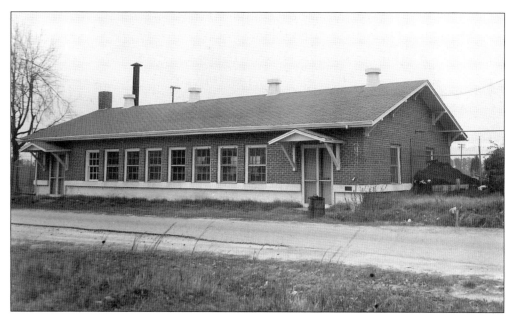

SIMPSONVILLE CANNERY. The Simpsonville Cannery building, located behind the Simpsonville Elementary School building along Jonesville Road, was staffed by the Hillcrest High School agriculture program for canning the vegetables of local farmers. The building was renovated in 1992 to become three classrooms, and is now a part of the First Baptist Church of Simpsonville. (Courtesy of the Greenville County School District.)

POTATO HOUSE. Constructed in the 1930s, the Simpsonville Potato House was behind the Simpsonville Elementary School Building along what is now Park Drive. For many years, residents could bring their sweet potatoes to the building to be stored seasonally. (Courtesy of the Greenville County School District.)

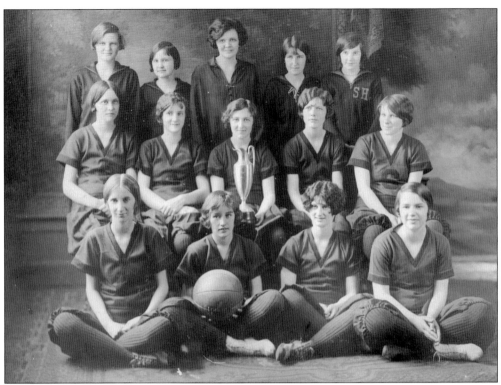

WHIRLWIND WOMEN'S BASKETBALL, 1926. The Simpsonville High School women's basketball team, known as the Simpsonville Whirlwinds, won an Upstate championship in 1926 and five state championships from 1923 to 1937. In the picture above are, from left to right, (first row) Louise Smith, Louise Calvert, Eloise Todd, and Catherine Austin; (second row) Charlotte Mayfield, Nell Hill, Shirley Jones, Madge Turner, and Mattie Mae Ashmore; (third row) Edna Barbrey, Ruth Whitmire, coach Helen Blakely, Mattie League Henderson, and Helen Christopher. (Above, courtesy of Dot and Lewis Cooley; below, courtesy of Brown and Pam Garrett.)

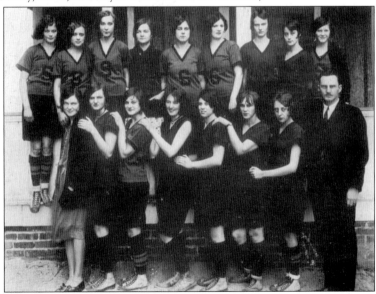

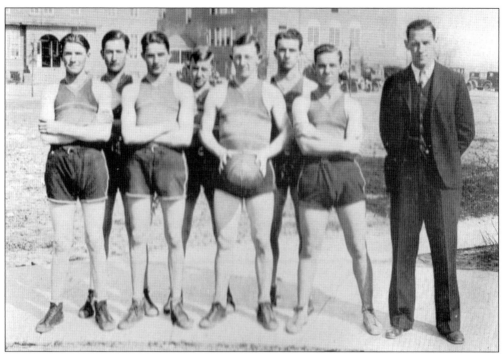

WHIRLWIND MEN'S BASKETBALL, 1920S–1930S. Members of the Simpsonville men's basketball team pose with (presumably) their coach in the 1920s or 1930s, with the 1907 and 1920 school buildings in the background. Sports were an important part of the high school throughout its history—the football team was also well known and practiced on a field behind the buildings pictured here. (Courtesy of Brown and Pam Garrett.)

SCHOOL GYM (ACADEMY STREET). When the WPA constructed the new Simpsonville School building on Academy Street in 1939, a gym and auditorium were built on opposite ends. One of the best examples of New Deal construction projects in the state, the gym still stands, with the wood on the upper walls preserved in its original state. (Courtesy of Geneva Lawrence on behalf of the City of Simpsonville.)

MAY DAY TRADITIONS. During the 1940s and 1950s, Simpsonville held an annual May Day Festival in conjunction with the local schools. Celebrations of May Day were common in the United States in the 19th and early 20th centuries, often associated with both labor and education—particularly education of women. Elements of the festivities included the maypole dance, which the women in these pictures are preparing for, as well as the preparation of May baskets. (Both, courtesy of Brown and Pam Garrett.)

MAY DAY FESTIVAL. Spectators observe the various activities of Simpsonville's May Day Festival in the 1940s or 1950s. Although any official ties to local education are undocumented, the festival took place adjacent to the Simpsonville School building on Academy Street. Visible in the background is the Agricultural Building, formerly housing the music college. (Collection of Georgene Rowe, courtesy of Doug Mayfield.)

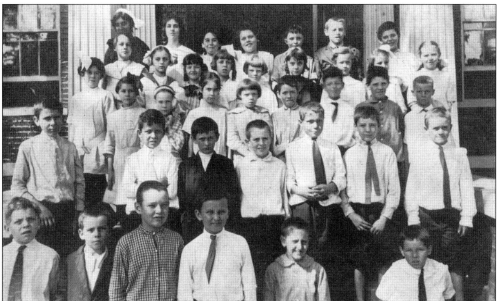

OAKLAWN SCHOOL. A group of students from the Oaklawn School, located to the west of Simpsonville, gathers for a group picture. Oaklawn School was one of several rural grammar schools that at one time fed students into Simpsonville High School for the higher grades. (Courtesy of the Greenville County Library System.)

Articles of an Agreement.

We whose names are hereunto subscribed, promise to pay or cause to be paid, unto John R Holland, for his services as a Teacher the following rates (viz) For Spelling, Reading, Writing and Arithmetic Eleven dollars per scholar, for the term of Ten Months. Also to furnish a suitable house to teach in. The said J R Holland binds himself to teach the above branches in the best manner he is capable, to give regular attention to his business, to keep good order, to make up all lost time (Public days excepted) To commence teaching with Twenty Scholars, and an open school to Thirty, School to commence January 1st 1855, and close November following.

Employers Names.		Employers Names
B Holland	1½	
Ny N Bramlette	1	
Singleton Stokes	½	
Reuben Bramlette	½	

PLINEY SCHOOL. Located in what is now the Five Forks area, the Pliney School served students on the northwestern edge of Simpsonville. In the document at left, John R. Holland is contracted to teach at the school. A frame structure was replaced by a brick structure in 1940, and the school was merged with other small local schools soon after. The front half of the building was later renovated for use as a fire department, with room to house four fire trucks. The building still stands, in use as the headquarters of the Clear Spring Fire Department, formerly the East Simpsonville Fire Department. (Both photographs by Christy Staton.)

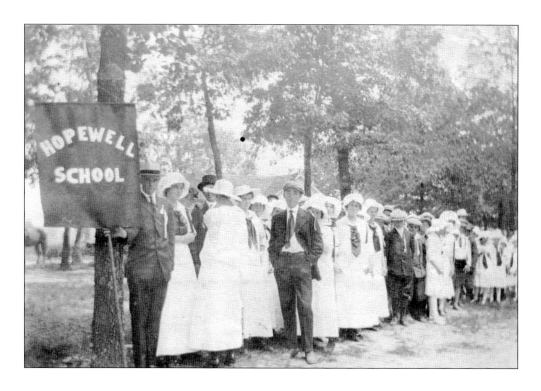

HOPEWELL SCHOOL. Above, a group of students from Hopewell School lines up for a picture. Associated with the Hopewell Methodist Church on the southwestern edge of Simpsonville, Hopewell School was one of several small grammar schools serving the outskirts of the area. (Both, courtesy of Carol Hightower Leake via Steve Cox.)

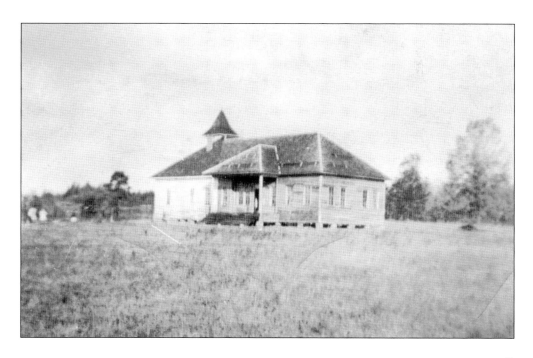

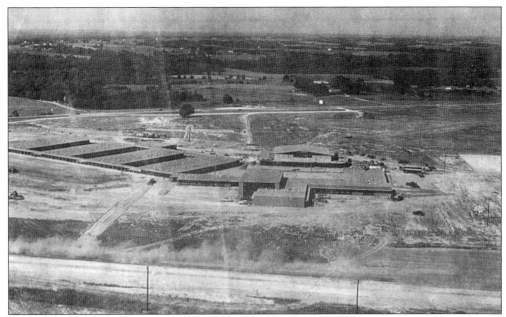

HILLCREST HIGH SCHOOL, 1957. A merger of Simpsonville High School students with neighboring Fountain Inn and Mauldin students resulted in Hillcrest High School. A site along Highway 276 was chosen to construct the new school, and the name was chosen from submitted suggestions, which also included "Triangle" and "Quil-Ma-Ville" in an effort to include the three cities, with "Quil" representing Fountain Inn native Robert Quillen. (Courtesy of Bryan Skipper on behalf of Hillcrest High School.)

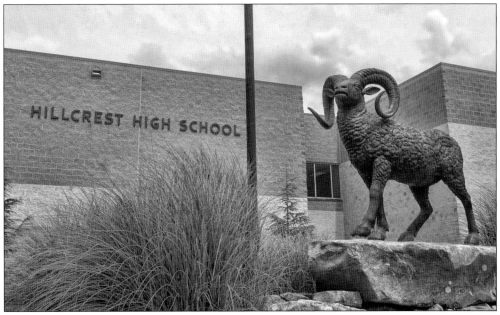

HILLCREST HIGH SCHOOL. The current Hillcrest High School building, located adjacent to the former structure (which became Bryson Middle School), opened in 1992 as an attempt to relieve overcrowding. The three-story structure currently accommodates over 2,000 students, rivaling Mauldin High School as the largest in the district. (Photograph by Christy Staton.)

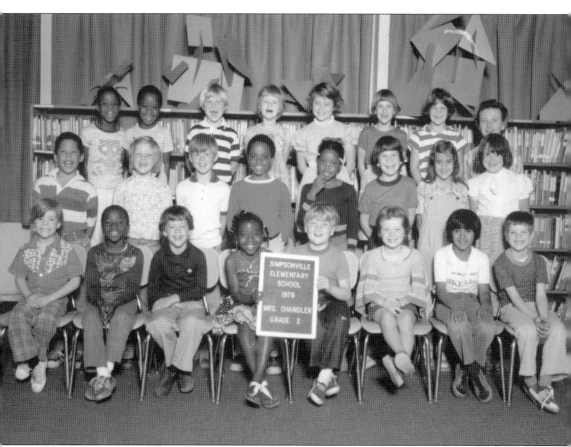

SIMPSONVILLE ELEMENTARY STUDENTS, 1977–1978. The students of Mary Anne Jones Chandler, one of the longest-serving teachers at Simpsonville Elementary School—having taught for over 30 years—gather for a class photograph in the school library. From left to right are (first row) Jerry Johnson, Mario Smith, Ricky W., Sherry Spurgeon, Carl Swanson, Julie Owens, Mark Adams, and Chris Allison; (second row) Tony G., Susan Lanier, Jimmy D., Michael Evans, Dorothy Mayfield, Ronnie B., Mandy Wood, and Christy Hill; (third row) Michelle A., Tammy Satterwhite, Neal Gross, Tracy Traynham, Keran A., Ashley Scott, Kelly Mills, and Chandler ?. (Courtesy of Christy Staton.)

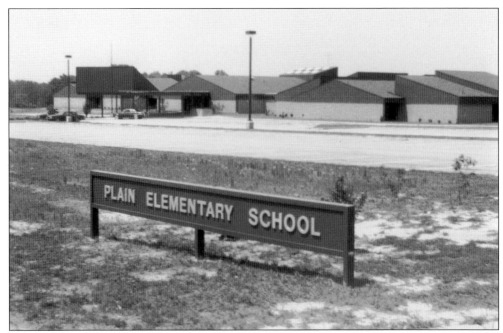

PLAIN ELEMENTARY SCHOOL. Opened in 1982, Plain Elementary School was constructed on the western side of Simpsonville to accommodate new housing developments such as Westwood. Deriving its name from the history of the town, Plain Elementary School has received several awards at the state and national levels. (Courtesy of the Simpsonville Area Chamber of Commerce.)

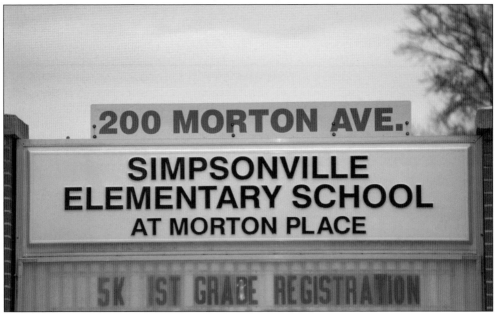

MORTON PLACE. In 2001, Simpsonville Elementary closed its doors at the former location in downtown Simpsonville as part of a large-scale reconfiguration of schools. Morton Elementary School was lost in the merger, becoming Simpsonville Elementary School at Morton Place. Bell's Crossing Elementary School also opened in 2003, drawing several students from the area. (Photograph by Christy Staton.)

Four

CHURCHES AND CEMETERIES

Religion has always played a very active role in the Simpsonville community, dating back to its very beginnings in the 1780s. The recently immigrated Peden family established Fairview Presbyterian Church in lower Greenville County in 1786; it was the first Presbyterian church in the county. Subsequently, congregations from other Protestant denominations began to form, resulting in the pioneering Bethel United Methodist Church, Standing Springs Baptist Church, Clear Spring Baptist Church, and Hopewell United Methodist Church, which all emerged as early religious hubs in the lower Greenville County area.

In the years that immediately followed Emancipation and the Civil War, the population of former slaves began to develop independent churches of their own, often with the help of local white residents. Cedar Grove Baptist Church, Old Pilgrim Missionary Baptist Church, and Bethlehem Baptist Church all arose from this movement. With the further development of the town in the late 19th and early 20th centuries, a number of "city church" congregations began to separate from the existing churches, including Simpsonville First Baptist Church, Simpsonville United Methodist Church, Simpsonville Church of God, and Simpsonville Presbyterian Church.

By the 21st century, so many churches of various faiths, denominations, and sizes have been created that it is nearly impossible to cover them all. Some of those that are not discussed in this chapter, but which still have an influential impact, include Beth Haven Baptist Church, Westside Baptist Church, St. Mary Magdalene Catholic Church, Brookwood Church, Advent United Methodist Church, Holly Ridge Baptist Church, East Georgia Road Baptist Church, Bethany Baptist Church, Discover Church, Faith Baptist Church, Word of Life Ministries, Christ Community Church, Poplar Springs Missionary Baptist Church, Kingdom Life Church, Bible Baptist Church, Grace Community Bible Church, a Church of Jesus Christ of Latter-day Saints (in the Verdmont subdivision), multiple Kingdom Halls of Jehovah's Witnesses, and many more.

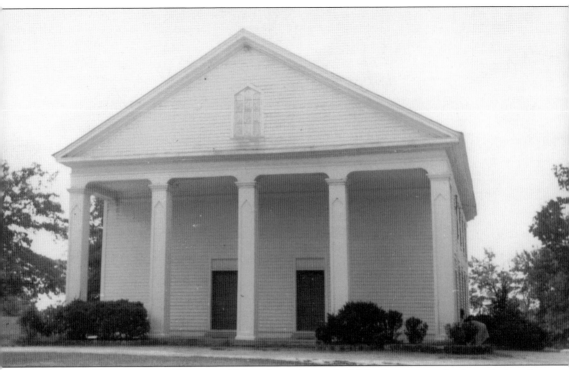

FAIRVIEW PRESBYTERIAN CHURCH. Although not located within the present-day boundaries of Simpsonville, Fairview Presbyterian Church to the south of the city had a profound influence over the development of the area. Largely founded by the Scots Irish Peden family, the church was organized in 1786 and has been housed in four buildings since that time. The first two were of log construction, the third of brick, and the fourth is a wood-frame structure built in 1858 that is still in use (pictured). These have each been located on roughly the same spot, adjacent to a cemetery framed by a stone wall. This cemetery contains the remains of seven Revolutionary War soldiers, along with a number of Confederate soldiers and prominent citizens. Fairview Presbyterian is regarded as the mother church of all Presbyterian churches in Greenville County, and the church's name—originating from the Irish countryside from which the Peden family had emigrated—lends itself to the busy commercial area of Fairview Road. (Courtesy of the Greenville County Library System.)

BETHEL UNITED METHODIST CHURCH. Located three miles northeast of Simpsonville, Bethel Church was another of the area's earliest places of worship. In 1801, well-known traveling Methodist minister Bishop Francis Asbury traveled to the area and began worship with local residents. Worship continued in area homes for a few years until John Bramlett deeded four acres for a log cabin church in 1810. Solomon and Benjamin Holland later gave additional adjoining land to the church for the purpose of annual camp meetings. The church has been housed in several buildings since that time, each located on the same spot next to the church cemetery. Pictured are male and female groups of Bethel congregants in the mid-1940s. (Both, courtesy of the Greenville County Library System.)

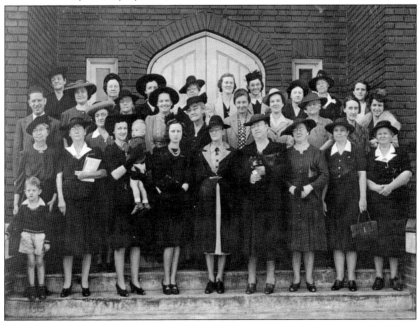

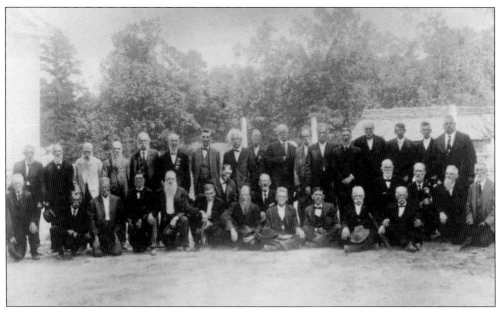

CONFEDERATE SOLDIERS REUNION. A group of Confederate veterans from the Simpsonville area gathers for a group photograph at the 1900 soldiers' reunion. This reunion was held annually on July 21 to commemorate the Battle of Manassas, in which most local soldiers fought. The reunion was held annually until too few veterans remained in 1934. (Courtesy of the Greenville County Library System.)

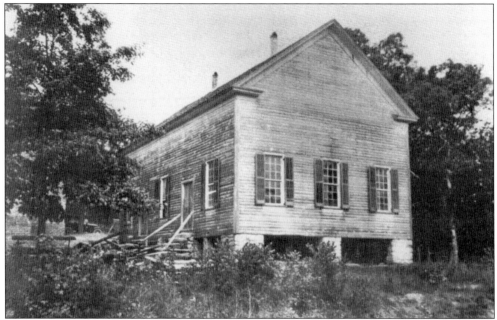

CLEAR SPRING MEETINGHOUSE, 1919. In April 1803, an extension of Brushy Creek Church was organized as Clear Spring Baptist Church, the oldest Baptist church in the Simpsonville area. In 1804, James Kilgore gave a portion of his property purchased in 1792 to construct a meetinghouse for the church. This wooden meetinghouse (pictured) served the congregation until a new building was commissioned in 1919. (Courtesy of Doug Mayfield.)

CLEAR SPRING BAPTIST CHURCH, 1920S.
After utilizing the wooden meetinghouse
for several decades, the leadership of
Clear Spring Baptist Church decided in
1919 that repairs to the building were
becoming too costly. T.F. McKinney and
11 others formed a building committee,
which commissioned the sanctuary
pictured here in 1919 and dedicated it four
years later in 1923. (Collection of June
Goodwin, courtesy of Doug Mayfield.)

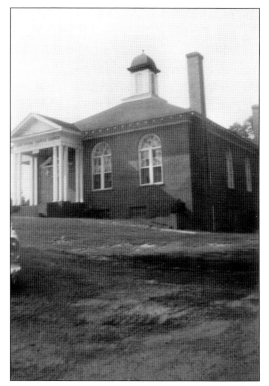

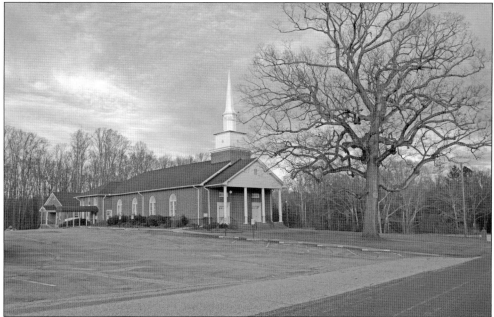

CLEAR SPRING BAPTIST CHURCH, 2015. The present Clear Spring Baptist Church retains the
overall structure of the 1923 building, but elements such as the steeple and facade have been
renovated or updated. The one-acre cemetery to the left of the church was laid out in 1854,
and the grand oak tree in front of the church is the last surviving tree planted for shade by Asa
Richards in 1922. (Photograph by Christy Staton.)

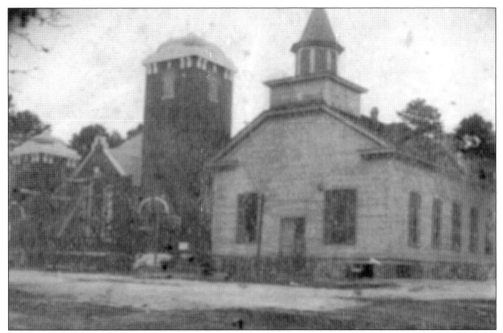

SIMPSONVILLE FIRST BAPTIST CHURCH. In 1887, B.M. Moore organized a Sunday school group in a small white schoolhouse near the center of town. The following year, this group formed a congregation and organized the First Baptist Church of Simpsonville, worshiping in the building pictured here from 1890 until a new chapel was erected in 1913. (Courtesy of Butch and Diane Kirven.)

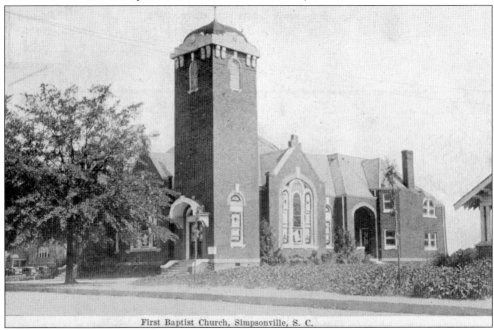

First Baptist Church, Simpsonville, S. C.

FIRST BAPTIST CHAPEL. By 1913, the growth of Simpsonville First Baptist Church warranted a new and larger building. Architect Luther Profitt designed the chapel with two iconic towers; large stained-glass windows were prominent features of the interior. The building still stands on Church Street, but was replaced as the main sanctuary in 1986. (Courtesy of Pat Henderson.)

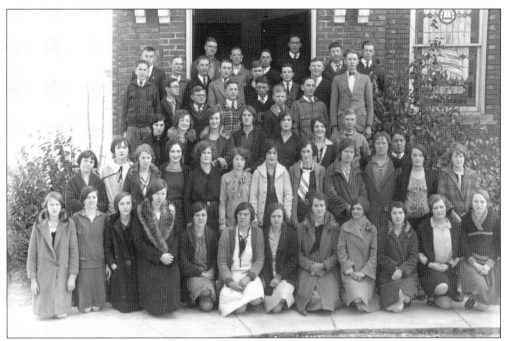

FIRST BAPTIST CONGREGANTS, 1940S. A group of worshipers from Simpsonville First Baptist Church gathers in front of the chapel entrance in the mid-1940s. Many of the most prominent families in Simpsonville's early history attended or helped to form Simpsonville First Baptist Church, and descendants of these families are still active in the church today. (Courtesy of the Greenville County Library System.)

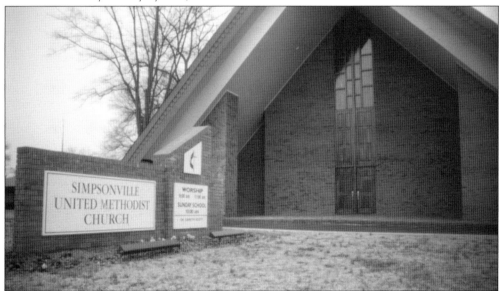

SIMPSONVILLE UNITED METHODIST CHURCH. Simpsonville's Methodist congregation began meeting in the Forum in 1916, and a church building designed by Henry Olin Jones was built shortly thereafter on Southeast Main Street. This building was later torn down and replaced in 1966 by the building pictured here, which still serves as the main sanctuary. (Courtesy of Geneva Lawrence on behalf of the City of Simpsonville.)

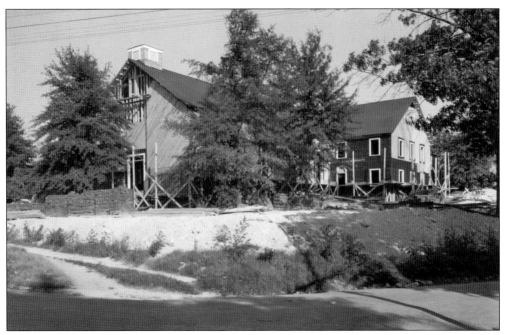

TEMPLE BAPTIST CHURCH, 1947. In 1914, a Sunday school group was organized in the Forum, the Simpsonville Woodside Mill recreational facility. The mill deeded a lot of land across South Street to the Baptist employees of the mill in 1924, and the Second Baptist Church was built. The church name changed to Temple in 1937, and by the 1940s, a growing congregation led to the construction of a new chapel. Tragedy struck, however, when the new building burned down in 1946 along with the church records. With the assistance of the Simpsonville Woodside Mill, a new chapel was built in 10 months, with construction (above) concluding in 1947. A renovation in 1994 expanded the church into its present state. (Above, courtesy of the Greenville County Library System; below, courtesy of the Coxe Collection, Greenville County Historical Society.)

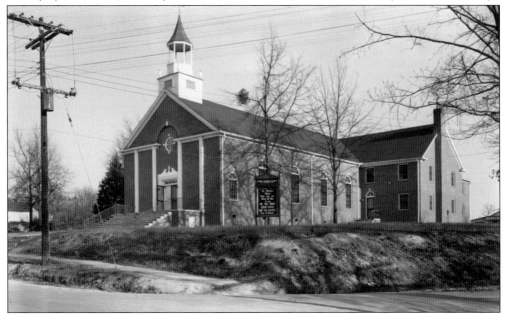

STANDING SPRINGS BAPTIST CHURCH. In 1818, a group of congregants from Fork Shoals Baptist Church began worship under Rev. Nathan Berry in a newly constructed small white chapel named for a spring about 200 yards away. New buildings were constructed in 1860 and 1915, with the church being moved farther uphill each time to its present site on West Georgia Road. (Photograph by Christy Staton.)

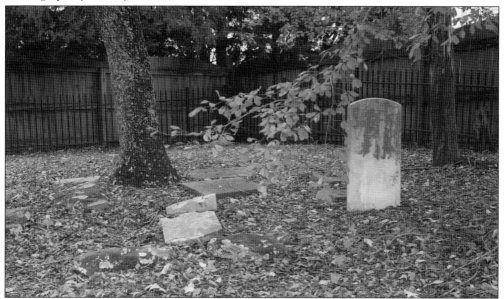

BENNETT GRAVES. A small cemetery containing the graves of John T. Bennett, his wife, Elizabeth, and several others marked by fieldstones can be found to the south of Harrison Bridge Road in the present Waterton subdivision. John T. was an early leader of the Standing Springs Baptist Church and associated Sunday school, teaching and serving as its superintendent. (Photograph by Christy Staton.)

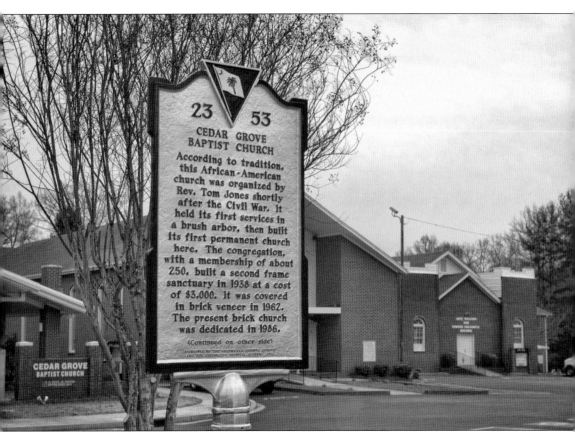

On the marker:

23 53

CEDAR GROVE
BAPTIST CHURCH

According to tradition,
this African-American
church was organized by
Rev. Tom Jones shortly
after the Civil War. It
held its first services in
a brush arbor, then built
its first permanent church
here. The congregation,
with a membership of about
250, built a second frame
sanctuary in 1938 at a cost
of $3,000. It was covered
in brick veneer in 1962.
The present brick church
was dedicated in 1986.

(Continued on other side)

CEDAR GROVE
BAPTIST CHURCH

CEDAR GROVE BAPTIST CHURCH. In the years following the Civil War, as former slaves began to build their own churches, calls for a church closer to the small downtown area of Simpsonville resulted in Cedar Grove Baptist Church, organized in 1870. The church lands were donated by Tom Moore, and a brush arbor was constructed in a grove of cedar trees—inspiring the church's name. Several church buildings have stood on the property, and a few of these still survive, attached to the most recent buildings with a different usage. The site of Cedar Grove Baptist Church once also contained the first African American school in the town and later the Simpsonville Rosenwald School. (Photograph by Christy Staton.)

56

OLD PILGRIM MISSIONARY BAPTIST CHURCH. In the years preceding the Civil War, slaves in the area east of Simpsonville were allowed to worship with the white congregants of Clear Spring Baptist Church. Following the war and Emancipation, the former slaves desired their own place to worship and were given land by Jesse Clayton Kilgore—the son of Josiah and grandson of area pioneer James Kilgore—who also helped to educate the former slaves. Behind the present church building are two cemeteries, the Kilgore Family Cemetery and Old Pilgrim's. Hundreds of unmarked or unreadable fieldstones mark graves in the latter cemetery, likely those of slaves owned by area families, and even more unmarked graves were discovered in the 21st century using new technology. (Photograph by Christy Staton.)

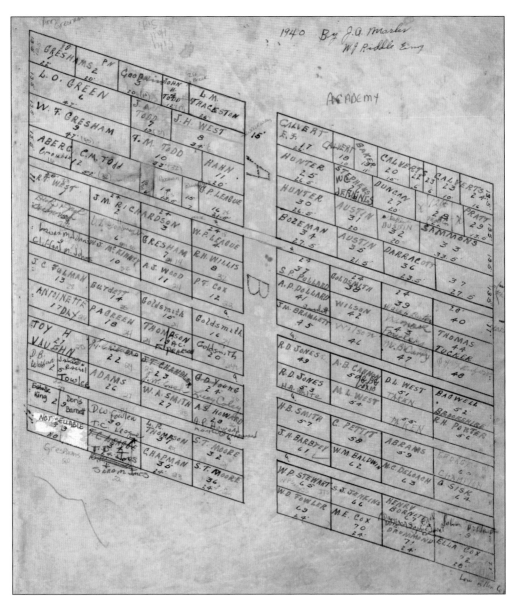

SIMPSONVILLE CITY CEMETERY. A cloth map, maintained until 1940 by the City of Simpsonville, displays the names of respective burial plot owners in the front portion of the Simpsonville City Cemetery. The first burial in the cemetery was Ann Moon Lynch in 1842, followed by her son Bannister Stone and his wife, Elizabeth Kilgore Stone. The most influential and prominent leaders of the Simpsonville area are buried at the cemetery, including seven of the town's mayors. The cemetery is located on Academy Street, on the block across from the two Simpsonville school buildings and the First Baptist Church. In the 1990s, the City of Simpsonville made the decision to allow the sale of the remaining plots in the cemetery. (Courtesy of Phyllis Long on behalf of Simpsonville City Hall.)

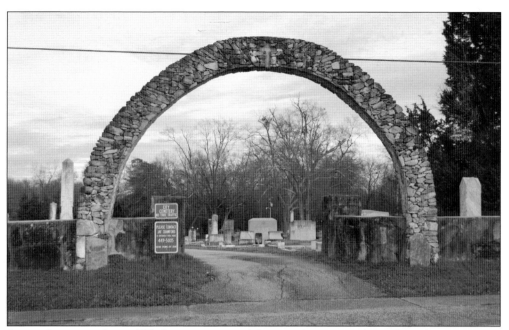

STONE CEMETERY ARCH. While not an original feature, the stone arch marking the entrance to the Simpsonville City Cemetery has become an iconic landmark in its own right. The stone wall predates the arch, which was laid by brickmason Joe Fowler. (Photograph by Christy Staton.)

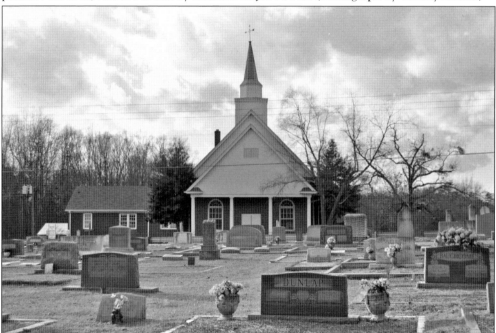

UNITY BAPTIST CHURCH. In 1900, a group of members from local Baptist churches, including Standing Springs, Simpsonville, and Fork Shoals, recognized the need for a new Baptist church to serve residents at a central point between the existing choices. George W. Richardson, the father of Dr. L.L. Richardson, was instrumental in organizing the church and is buried in the church cemetery along with his family. (Photograph by Christy Staton.)

HOLY CROSS EPISCOPAL CHURCH. Among the more recent additions to Simpsonville's religious landscape is Holy Cross Episcopal Church, presently located at the intersection of Jonesville Road and College Street. The church was first organized in the 1950s in a small building on Harrison Bridge Road. This building was then moved to the present site, and two newer sanctuaries were later constructed to accommodate growth. (Photograph by Christy Staton.)

CALVARY BAPTIST CHURCH. The steeple of Calvary Baptist Church is removed while a new sanctuary is constructed in 2012. Rev. Guy Altizer began the church on West Curtis Street in 1985, and in 1988 the congregation purchased 13 acres on Grandview Drive to construct a permanent facility. The church grew over the following decades, and now consists of two sanctuaries, a youth center, a gymnasium, and an office building. (Photograph by Christy Staton.)

Five

BUILDINGS AND BUSINESSES

As with any place that wishes to have a strong and prosperous community, the economic sector of Simpsonville is crucial to the success of the town. For several decades spanning several generations of residents, businesses have come and gone but left their marks on the town by providing quality goods and materials to build a healthier community. A sampling of the many varieties of stores throughout Simpsonville's history is presented in this chapter, which unfortunately leaves out several stores that are fondly remembered and sorely missed by Simpsonville's longtime residents.

One of the most beloved and frequently discussed former businesses in the city is Ruth Thackston's store, located on South Street across from the textile mill. Many longtime and former residents remember visiting the store as children, picking out candy and playing with the old cash register. The store was legendary during its years of operation, even scoring visits from figures such as Sen. Strom Thurmond and Gov. Dick Riley (a former Simpsonville resident himself). Ruth's store was one of many grocery and convenience stores at the time, another being Cooper's Cut Rate Grocery. Service stations were also common in Simpsonville in the mid-20th century; a number are presented in this chapter. Those not pictured include Barbrey's (now Danny's), Roy King's, Mahaffey's Sinclair, and Leak's.

Architecturally speaking, many Simpsonville buildings that housed not only businesses but also homes and churches have a number of qualities that make them unique and spectacular. While only two buildings within the city limits of Simpsonville are currently listed in the National Register of Historic Places—the Burdette Building and the First Baptist Chapel—several other buildings and historic sites are eligible for listing, most notably the Simpsonville Elementary School building constructed by the WPA in 1939.

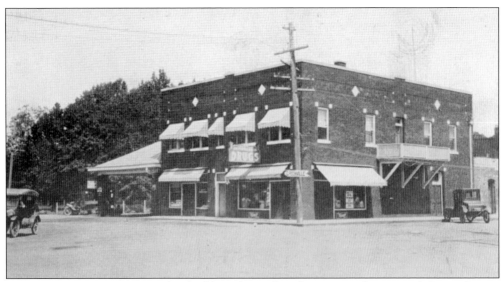

SIMPSONVILLE DRUG STORE. This building, located at the corner of Main and Curtis Streets in downtown Simpsonville, was originally built by Sidney J. Wilson as the first brick building in town. The original structure was rebuilt at a later date, reusing all of the bricks along with several new ones. The Simpsonville Drug Store was housed here for many years. (Courtesy of Pat Henderson.)

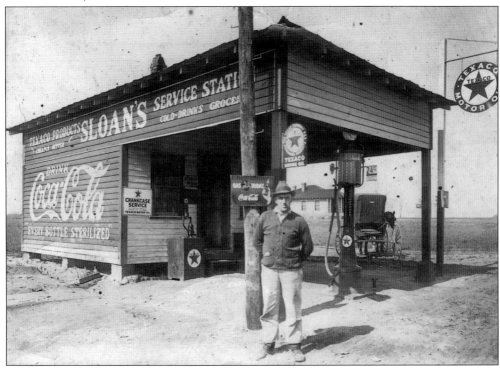

SLOAN'S SERVICE STATION. Raymond Sloan stands in front of his Texaco service station at the intersection of Highway 14 and Main Street. Later in Simpsonville's history, Sloan and his family owned and operated a grocery store downtown, as well as a feed and seed that still operates near the site of the former service station. (Courtesy of Doug Mayfield.)

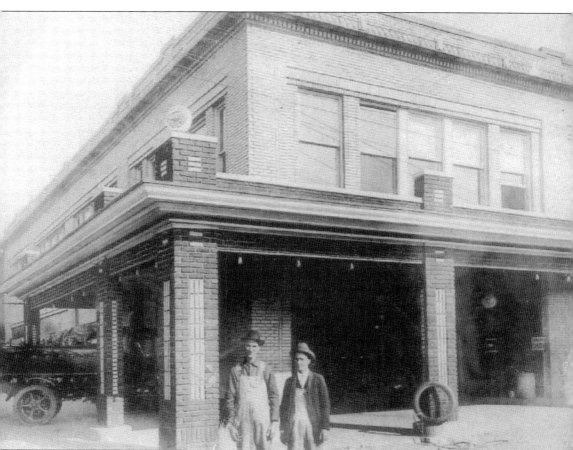

BURDETTE BUILDING. In 1899, B.W. Burdette and his brother D.W. Burdette purchased the lot at the corner of East Curtis and Main Streets, and constructed a two-story wood-frame building. A brick portion of the building was added in 1912 along with a brick façade on the north side, but in 1921, a fire destroyed the wooden building, leaving only the brick additions. Under the strict supervision of B.W., it was rebuilt in brick, resulting in the edifice that still stands today. The corner of the building was once used as a gas station, with a brick extension covering the cars (pictured here in 1923 with Dock and Reid Jones in the foreground). This extension was demolished in the late 1980s. Still visible on the rear of the building in faded paint is the name B.W. Burdette & Bros. Grocery & Hardware. Burdette Hardware was sold to the McCraw family and moved up Main Street in the 1980s. (Courtesy of Pat Henderson.)

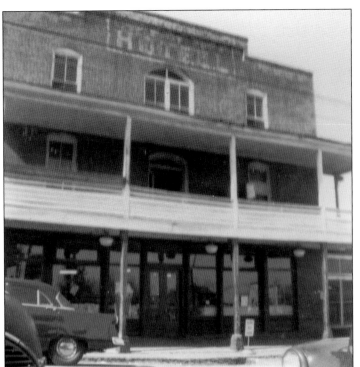

GRESHAM'S FOOD STORE. Following Simpson Curry's ownership of the downtown Simpsonville hotel, the building was owned by William Perry Gresham, who moved his grocery store into the structure. Gresham first opened the store with George W. Greene in 1890, in a store facing the railroad. The grocery store continued with W.P. Gresham's sons, W.F. and J.O., then with W.F.'s son Metz. (Courtesy of Brown and Pam Garrett.)

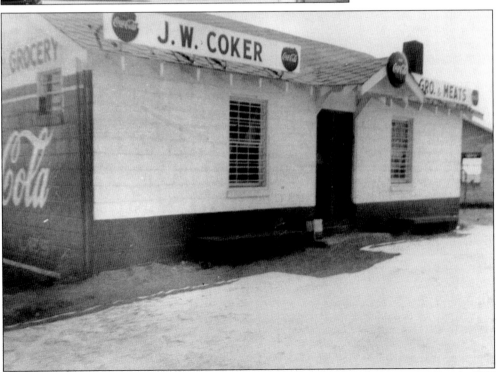

J.W. COKER. Located at the intersection of West Georgia and Standing Springs Roads, J.W. Coker Grocery and Meats operated for a number of years in the mid-20th century. The building is pictured here in the 1950s. (Collection of James Coker, courtesy of Doug Mayfield.)

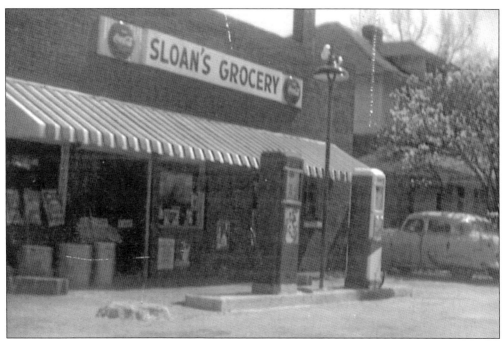

SLOAN'S GROCERY. Located on Southeast Main Street, the exterior and interior of Sloan's Grocery are pictured here. In the interior photograph, the man at far left is Raymond Sloan, who also owned Sloan's Service Station at the intersection of Highway 14 and Main Street above Simpsonville. The other men are, from left to right, Perry Haynes, Jones B. Thackston, Sam Sloan, Henry Hammond, and Alton Baldwin. The building that housed Sloan's Grocery has been preserved and is now the site of Extreme Tees. (Both, courtesy of Doug Mayfield.)

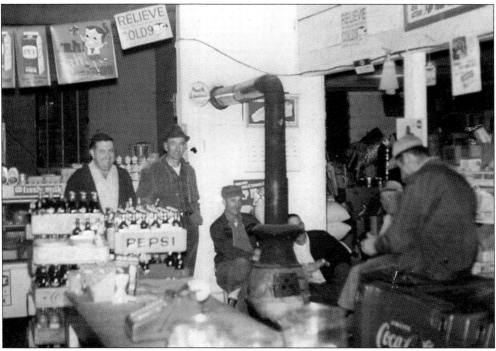

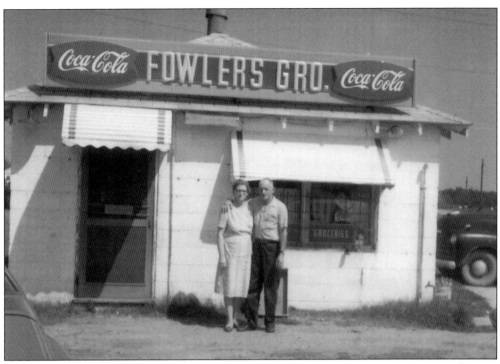

Fowler's Grocery. Drew "Doodle" Fowler and his wife, Dorcas Aluwee Watson Fowler, stand in front of their grocery store, located at the intersection of Fowler and East Georgia Roads. (Collection of Judy Fowler, courtesy of Doug Mayfield.)

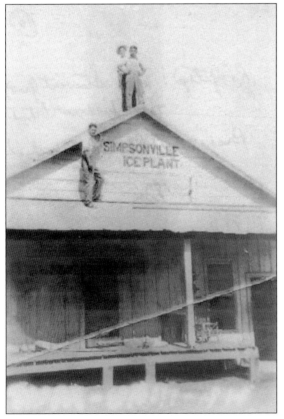

Simpsonville Ice Plant. Wallace Stewart (roof, front), Lloyd "Pap" Childress (roof, back), and Alender Hughes (porch) stand atop the Simpsonville Ice Plant in 1926. Located on Hedge Street, the building was open for local residents to bring large chunks of ice before refrigerators were available to store it in their homes. (Courtesy of Pat Henderson.)

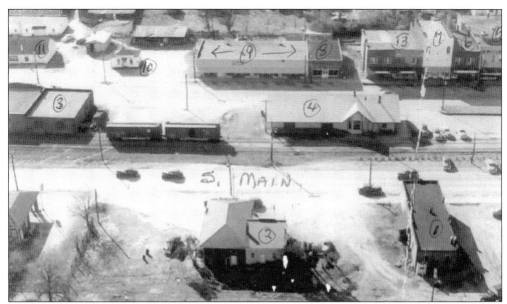

SOUTH MAIN BUSINESSES. The commercial downtown strip of South Main and Southeast Main Streets is seen from above in the 1950s. At center is the former train depot, at top center is a strip mall currently housing Rotary Hall, and at bottom center is Thackston's Filling Station. (Courtesy of Pat Henderson.)

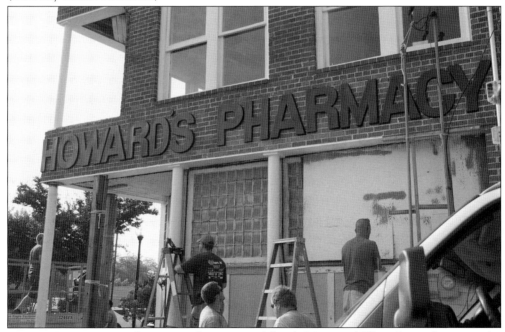

HOWARD'S PHARMACY. Sitting on the corner of South Main and West Curtis Streets is the Howard's Pharmacy building, constructed in the early 1900s. The pharmacy was opened in 1934 by Price and Fred Howard and has seen several owners since that time—including Wilton and Furman Chandler, Luona Goodwin, Eddie Howard and Lewis McDonald, and Billy McWhite and John Janik. The building was restored in 2011, when the original windows pictured here were uncovered. (Photograph by Christy Staton.)

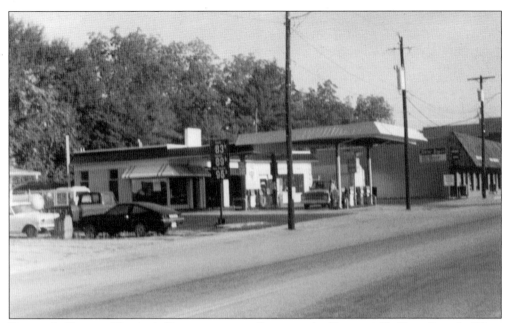

FLEMING'S GARAGE. Fleming's Garage once sat adjacent to the Simpsonville Drug Store building on Northeast Main Street. The station was demolished in the 1950s and replaced by a bank building, which remains on the site. The wall of the Simpsonville Drug Store building where Fleming's once was now features a mural, titled *Balancing Act*, which represents Simpsonville history. (Collection of Glenn Fleming, Courtesy of Doug Mayfield.)

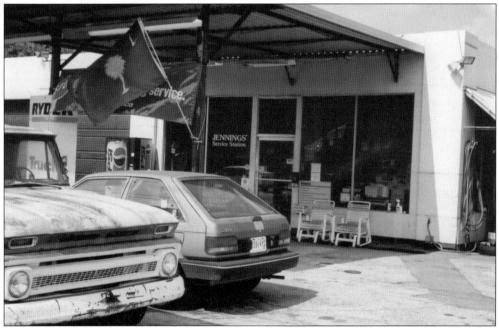

JENNINGS' SERVICE STATION. Owned and operated by twins Wade and Waymon Jennings, Jennings' Service Station was located on Northeast Main Street, adjacent to the Simpsonville Gun and Pawn Shop. Upon Wade and Waymon's deaths, the station was operated by Waymon's son Clifford until it closed in 2007. (Courtesy of Doug Mayfield.)

GOODWIN'S GARAGE, 1946 AND 1990. Above, Toy and Claude Goodwin pose in front of a newly constructed Goodwin's Garage in 1946, located on Hedge Street. Below, the Goodwin's Garage building stands empty in 1990. It has since been demolished. (Above, collection of Dale Goodwin, courtesy of Doug Mayfield; below, photograph by Doug Mayfield.)

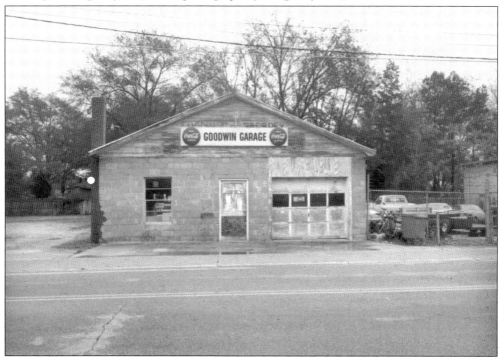

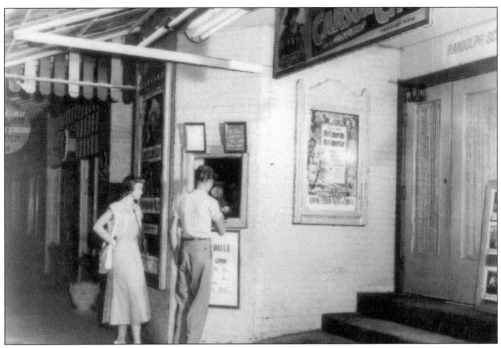

Royal Theatre

Simpsonville, S. C.

--Presents--

Monday and Tuesday, Aug. 28-29

"The Adventures of Mark Twain"

---Starring---

FREDERIC MARSH and ALEXIS SMITH

Monday Morning Matinee 10:30 a. m.

Monday Afternoon Matinee at 3:15 p. m.

Monday Night Shows at 7:15 and 9:30 p. m.

Tuesday Afternoon Show at 3:15 p. m.

Tuesday Night Shows 7:15 and 9:30 p. m.

LATEST MGM NEWS OF THE DAY

ADMISSION—12c and 32c

It's Always Cool and Comfortable at the Royal

ROYAL THEATRE. Above, a couple purchases tickets to a movie showing at the Royal Theatre. The woman is Joan Thackston; the man is unidentified. Located on South Main Street in downtown Simpsonville (now the site of Me Salon and Day Spa), the theater building was constructed in 1907 and originally housed a hardware and woodworking shop. In 1934, seats and a projection booth were added to convert the building into a theater, which offered admission for 12¢ or 32¢ (as illustrated by the advertisement at left). The Royal Theatre closed in the 1950s and the Ville-Inn drive-in theater opened between the cities of Simpsonville and Fountain Inn. (Above, courtesy of Pat Henderson; left, courtesy of Doug Mayfield.)

JONES FURNITURE STORE. The T.E. Jones furniture store was one of the most prominent early businesses of downtown Simpsonville. Founded by Thomas Eugene Jones, the store was originally located in the current Carolina Olive Oil building on South Main Street. It later moved around the corner to a larger storefront on West Curtis Street, visible in the background of this photograph from 1952. (Collection of Georgene Rowe, courtesy of Doug Mayfield.)

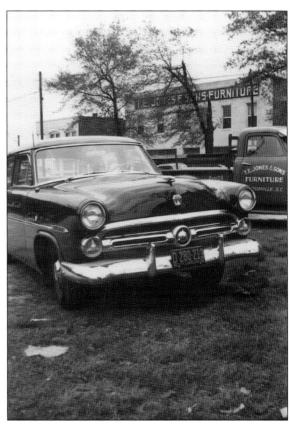

FOWLER'S RADIO AND TV. Pictured in the 1950s, Fowler's Radio was located on West Georgia Road. The store was owned by James Arthur Ray Fowler Sr., and in the 1960s was modernized to become Fowler's TV Sales and Service. The store closed in the late 1990s when Fowler was in declining health. He passed away in 2001. (Collection of Pat Fowler, courtesy of Doug Mayfield.)

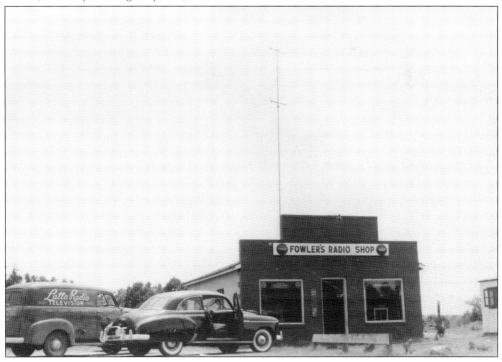

EAST GEORGIA HOMES. This 1950s aerial photograph of the East Curtis/East Georgia Road area shows several homes that no longer stand. The F. Morgan Todd home, Gresham home, Wood home, and Burdette home (labeled 1, 2, 4, and 5 respectively) have all been demolished, the latter two to make way for the police and fire departments. (Courtesy of Pat Henderson.)

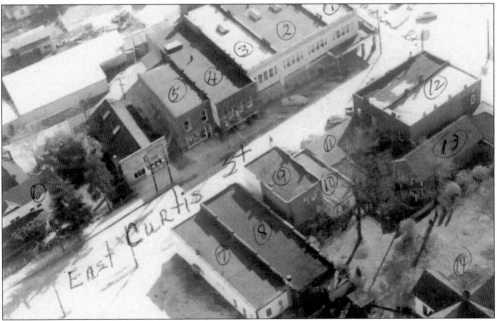

EAST CURTIS BUSINESSES. The businesses lining East Curtis Street are pictured from the air in the 1950s. The Burdette Building, labeled 1 through 5, is seen before a fire in 1969 heavily damaged the main structure and destroyed most of the hardware store portion. Additional buildings include the former two-story city hall, labeled 9, and the former Bozeman home, labeled 14. (Courtesy of Pat Henderson.)

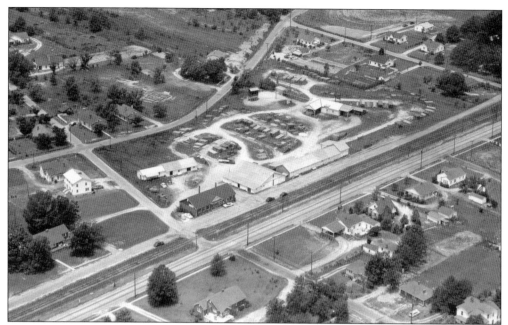

HENDRICKS BUILDING SUPPLY. Located between North Main and Maple Streets, the former Simpsonville Lumber Company is pictured in the 1950s. In the 1960s, the company was purchased by Ralph Hendricks and became Hendricks Building Supply. Using his business, Hendricks worked to develop several neighborhoods around the area, pushing Simpsonville into a period of unprecedented growth. (Courtesy of Doug Mayfield.)

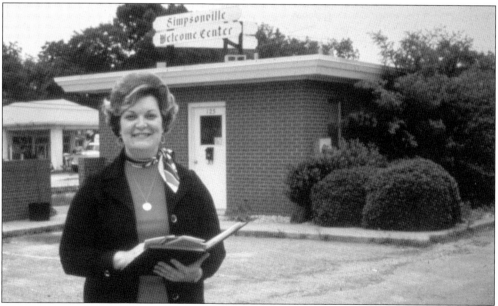

SECOND TRAIN DEPOT. In 1966, the mayor and city council made the decision to demolish the original wooden train depot on Main Street in order to construct a new, smaller brick depot. This was completed in the following year, resulting in this depot that housed the chamber of commerce and welcome center for a number of years. Bonnie Gregory, director of the welcome center, is pictured. (Courtesy of the Simpsonville Area Chamber of Commerce.)

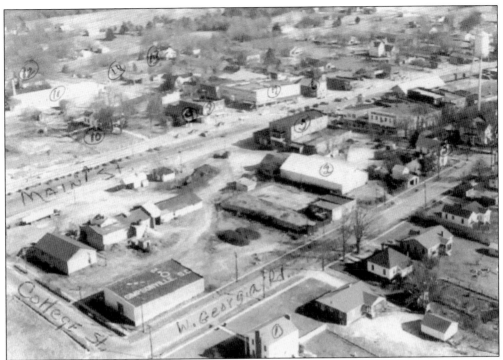

COTTON GIN AND JAIL. A block of downtown Simpsonville, now containing a shopping center, is seen here in the 1950s. A large cotton gin formerly occupied the area at lower left, while the first city jail sat toward Main Street in the middle of the block. (Courtesy of Pat Henderson.)

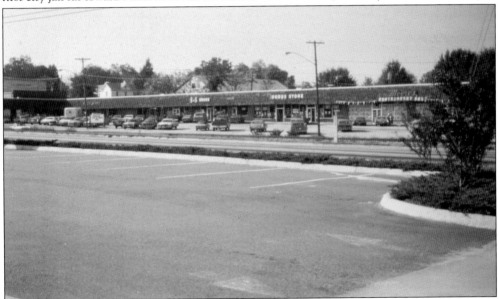

MOORE'S SHOPPING CENTER. B.C. Moore's, Dodd's Store, J+J Drugs, a jewelry store, Food Mart, and Western Auto occupy the shopping plaza on South Main Street between College and Curtis Streets around 1975. This shopping center was constructed in 1963, and is currently occupied by businesses and restaurants such as Upstate Karate and Henry's Smokehouse. (Courtesy of Geneva Lawrence on behalf of the City of Simpsonville.)

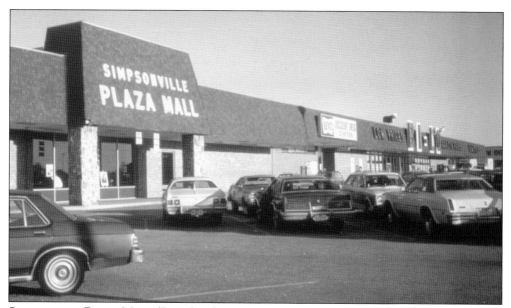

SIMPSONVILLE PLAZA MALL (BI-LO). The Simpsonville Plaza was built along South Street just north of Fairview Road and was anchored by the Bi-Lo grocery store pictured here around 1980. Bi-Lo relocated elsewhere in the same plaza before moving to Fairview Road in the early 2000s, and Moore's relocated from South Main Street to Simpsonville Plaza. (Courtesy of Geneva Lawrence on behalf of the City of Simpsonville.)

THE PANTRY. Located next to Jennings's Service Station, the Pantry was a convenience store visible at far left in this view from 1991. Not visible to the far right is the site of the former Winn-Dixie and Hometown Food Store, which burned in 1987, and the present Simpsonville City Hall constructed on the site. (Courtesy of Doug Mayfield.)

COX STREET GARAGE. A small garage at the intersection of Richardson and Cox Streets is pictured after the events of September 11, 2001. The garage was formerly owned by Truman Campbell, who used the building as a shop to repair loom parts for the mill. It was also used as an auction house, with a faded "Pennington's Auction House" still visible on the side. (Courtesy of Dayna Hill.)

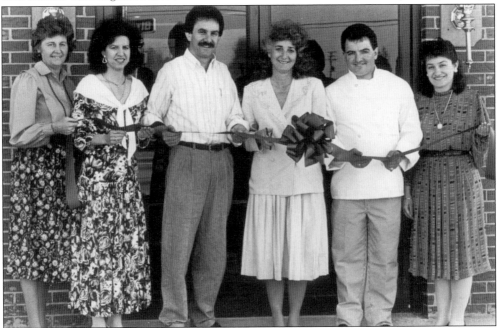

COACH HOUSE RESTAURANT. The grand opening of the Coach House Restaurant is celebrated with a ribbon cutting in 1991. Mayor Pam King is cutting the ribbon, while co-owners Spiro Eliopoulos and Johnny Mastrokolias stand left and right of her, respectively. The pair owned the restaurant together until Mastrokolias's death in a 2013 car accident. It continues today under the leadership of Eliopoulos. (Courtesy of Spiro Eliopoulos and Coach House Restaurant.)

SIMPSONVILLE SENIOR AND ACTIVITY CENTER. In the 1990s, the City of Simpsonville decided to construct a larger facility to house the city's parks and recreation program as well as providing space for community activities. The site of the Woodside Gym was chosen for the project, and the city chose to preserve the gym and incorporate it into the structure of the building. Two existing houses were moved to make room for a second, larger gym, and two stories were designed to connect the gyms, containing offices, an expansive fitness area, and community activity rooms. The building opened with a ceremony in September 1998 and is still in use. The fitness area was later reduced, to provide a more permanent space for a senior program serving over 800 seniors. Additionally, the Simpsonville Genealogical Research Room opened a space in the building in 2015. (Both, courtesy of Robbie Davis.)

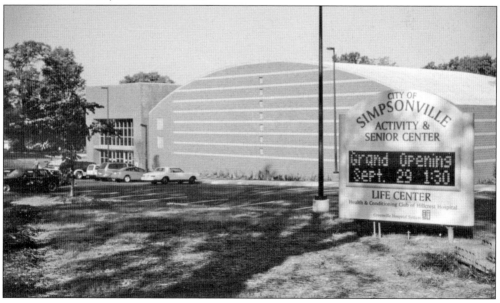

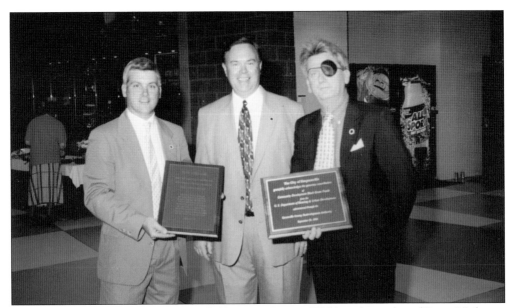

THREE CITY OFFICIALS. Robbie Davis (left), Mayor Dennis Waldrop (center), and Barry Hickman pose at the grand opening of the Simpsonville Senior and Activity Center in 1998. Davis has served as the city's parks and recreation director for 20 years and was honored by the South Carolina General Assembly in 2011. Hickman served as the city administrator for seven years, from 1995 to 2002. (Courtesy of Robbie Davis.)

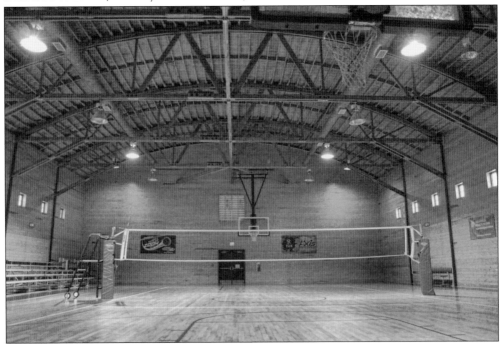

WOODSIDE GYM INTERIOR. The interior of Woodside Gym is pictured in 2015. Having been renovated and adapted into the current Simpsonville Senior and Activity Center building, the structure has been threatened on several occasions but still retains much of its original wood and materials. (Photograph by Christy Staton.)

Six

PEOPLE AND FAMILIES

For many years in Simpsonville, a number of people and families have unsuccessfully attempted to pinpoint a single parental figure or family in the town's history. While it would be easy to claim figures such as Peter Simpson, the town's namesake, or the Austin family, the first settlers to the area, as the catalysts for present-day Simpsonville, the true title belongs to a large group of people who have all contributed to make Simpsonville the vibrant city that it is today.

Regarding figures of leadership within the city, it is necessary to discuss the succession of mayors in the 115 years since the town charter was issued in 1901. Simpsonville has had 17 mayors since the inaugural Collier McDuffie Todd leadership: J.O. Gresham Sr., George W. Goodwin, Thomas L. Henderson, Daniel E. Lineberger, Edwin H. Gresham, George H. Jones, Roy P. Gaines, Florence M. Todd, Dr. Lawrence L. Richardson, Steve W. Hiott Jr., R.L. "Penny" Richardson, Ralph W. Hendricks, J.L. "Lanny" Montgomery III, Pamela O. King, Dennis C. Waldrop, Perry R. Eichor, and Janice S. Curtis. There have been two instances in which the mayor pro tempore of Simpsonville acted in a mayor's absence until an election could be held; these individuals were Robert Hamby and Geneva Lawrence. One particularly interesting facet of Simpsonville's governing history is the strong presence of women, which has steadily increased since Shirley Jones was elected as the first city councilwoman in the 1950s, culminating in the election of the first female mayor in 1991 and the first female council majority in 2015.

While figures of public safety, such as chiefs of police and fire, are discussed at greater length in chapter eight, the roles of city attorney and city administrator are also noteworthy as they have traditionally become launchpads for political careers at the state or national level. Future South Carolina governor and US secretary of education Richard "Dick" Riley served as Simpsonville city attorney in the 1960s, and current South Carolina state representative Garry Smith served as the city administrator in the 1990s.

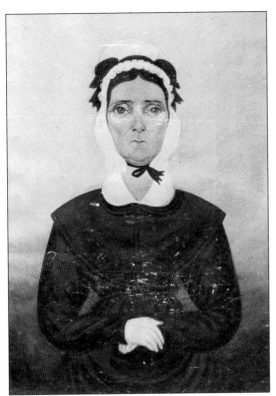

KEZIAH GREER KILGORE. Born in 1768 to William Greer and Mary McCurdy Greer, Keziah Greer married James Kilgore in 1787 and together they were among the earliest residents of the Simpsonville area. James and Keziah had nine children and owned much of the land east of Simpsonville, including the present Five Forks and Clear Spring areas. (Courtesy of Joe Harris Kilgore, Jean Kilgore Weeks, and Debbie Weeks.)

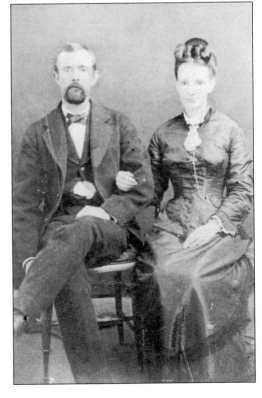

JOSIAH AND MARY KILGORE. Josiah Stanley Kilgore and his wife, Mary Dunklin Kilgore, sit for their wedding portrait in 1876. Josiah was the son of Dr. William Clark Kilgore, grandson of Josiah Kilgore, and great-grandson of James and Keziah Greer Kilgore, and was a prominent resident of the Clear Spring Baptist Church community. (Courtesy of Joe Harris Kilgore, Jean Kilgore Weeks, and Debbie Weeks.)

W.P. AND CAROLINE GRESHAM. William Perry Gresham and Caroline Elizabeth Jones Gresham were instrumental in the founding of Simpsonville. Having 11 children, who almost all continued to contribute to Simpsonville, the couple was involved in the founding of the town, the First Baptist Church, a hotel, and a grocery store on Main Street. (Courtesy of Joe Harris Kilgore, Jean Kilgore Weeks, and Debbie Weeks.)

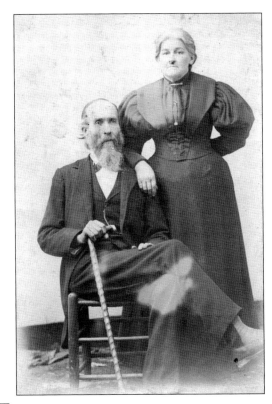

JONES SISTERS. Caroline Elizabeth Jones Gresham (left) and Elvira Jones (right) were children of Andrew Jones and Agnes Harbin Jones. (Courtesy of Bill Gresham.)

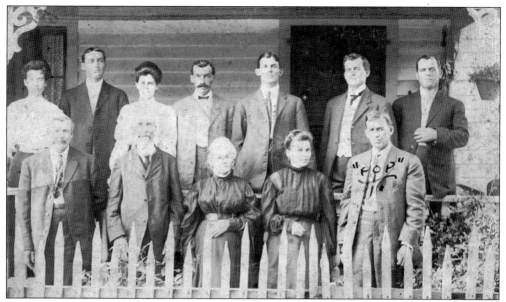

GRESHAM FAMILY. William Perry Gresham and Caroline Jones Gresham stand with their children at their home, located at the corner of Maple and Curtis Streets. From left to right are (first row) Ira Gresham, W.P. Gresham, Caroline Jones Gresham, Leila Gresham Green, and Levi Alexander Gresham; (second row) Carrie Gresham Bramlett, Manly Gresham, Mattie Gresham Todd, Perry Gresham, Edwin Gresham, W. Frank Gresham, and John Gresham. (Courtesy of Bill Gresham.)

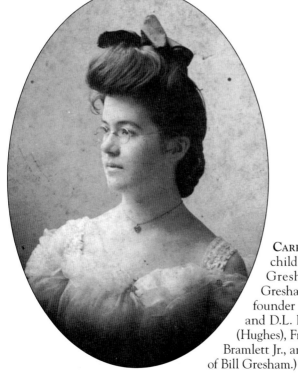

CARRIE GRESHAM BRAMLETT. The youngest child of William Perry and Caroline Jones Gresham, Caroline Elizabeth "Carrie" Gresham married Decatur Lee Bramlett, the founder of the Bank of Simpsonville. Carrie and D.L. had four children—Carolyn Bramlett (Hughes), Frances Cornelia Bramlett, Decatur Lee Bramlett Jr., and Martha Bramlett (Hiott). (Courtesy of Bill Gresham.)

J.O. Gresham Sr. John Oswall Gresham, one of William Perry and Caroline Jones Gresham's children, was the second mayor of Simpsonville, serving from 1903 to 1905. John's brother-in-law Collier Todd was the first mayor, and his brother Edwin was the sixth mayor. John is pictured here in his wedding picture with his wife, Bessie Jane Welborn Gresham. (Courtesy of Joe Harris Kilgore, Jean Kilgore Weeks, and Debbie Weeks.)

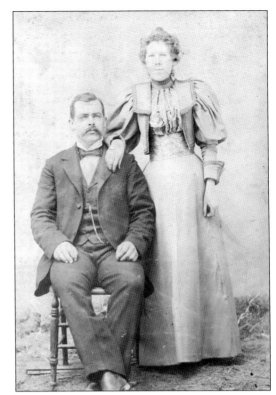

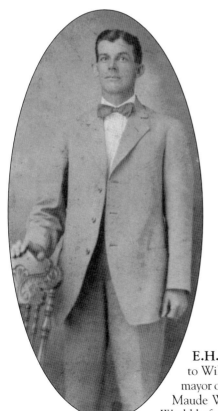

E.H. Gresham. Edwin Hampton Gresham, born in 1875 to William Perry and Caroline Jones Gresham, was the sixth mayor of Simpsonville, serving from 1910 to 1912. Edwin married Maude Willingham and was active with the Woodmen of the World before his death in 1928. (Courtesy of Bill Gresham.)

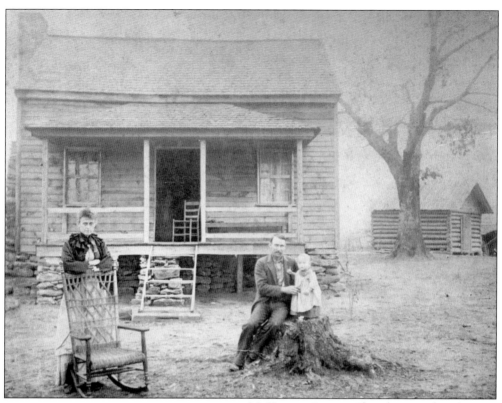

MCKINNEY FAMILY. This photograph, taken around 1896, depicts James A. McKinney; his wife, Martha Jane "Mattie" Vaughn McKinney; and their son Clarence C. McKinney (standing on the stump). The picture was likely taken at the family's residence on Jonesville Road, beside the present Bells Crossing Elementary School near the intersection with Scuffletown Road. (Courtesy of Doug Mayfield.)

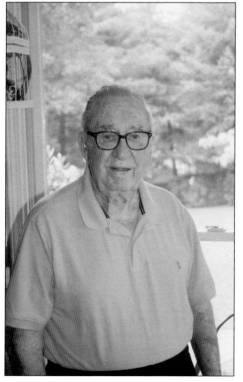

MORRIS MCKINNEY. T. Morris McKinney, the only son of Clarence C. McKinney, moved to Simpsonville when he was nine years old and graduated from Simpsonville High School. He entered the Army Air Corps after completing high school, flying 74 missions during World War II. He returned to Simpsonville, and married Mary Jane Curry in 1953. Mary Jane taught at Simpsonville and Hillcrest High Schools for a number of years. Morris passed away in 2016. (Courtesy of Gary Fann.)

Harrison Family. James Harrison, of the prominent Harrison family of lower Greenville County, and his wife are shown in their wedding portrait. The history of the Harrison family in the area dates to the late 18th century, when the family owned what is now the Hopkins Family Farm before it was purchased by the Hopkinses. Harrison Bridge Road is also named for the family's influence on the area. (Collection of Carol Hightower Leake, courtesy of Steve Cox.)

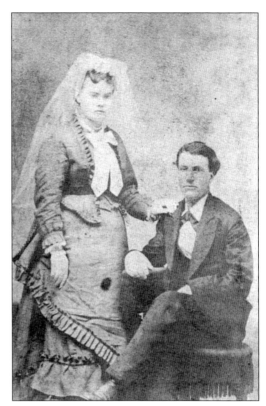

Willie Elizabeth Cox. Born in Simpsonville in 1906 to William Henry Cox and Emmie Jane Greene Cox, Willie was educated in the Simpsonville schools until her graduation in 1923 from Simpsonville High School. She married Thomas Clayton Ray and moved to Clinton, South Carolina, where she taught in the local schools for 27 years. (Courtesy of Darin Bridgeman.)

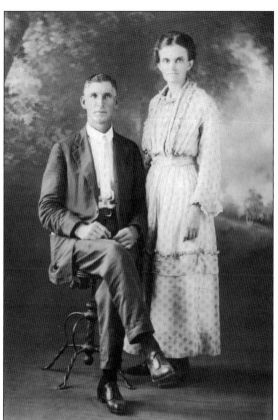

M.P. AND F.C. BROWN. Marcus Pomeroy Brown and his wife, Florence Clark Brown, are pictured together. He was the owner of a grocery store in downtown Simpsonville, where he sold "staple and fancy groceries." (Courtesy of Brown and Pam Garrett.)

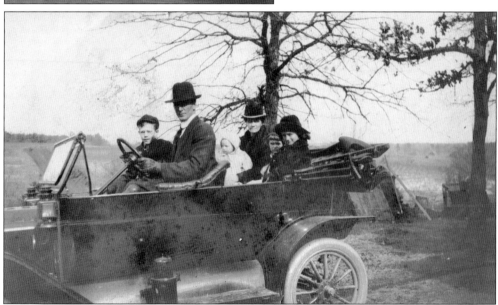

BROWN FAMILY. The family of Marcus Pomeroy Brown and Florence Clark Brown ride in the family's car. The couple had five children—Joseph Marlo Brown (1904–1916), Lois (Brown) Abbott (1907–1998), Edith (Brown) Balcome (1910–1994), Florence Mark Brown (1914–1952), and Marie (Brown) Garrett (1918–2008). (Courtesy of Brown and Pam Garrett.)

GIRL GROUP. A group of eight female students of Simpsonville schools gathers for a group photograph. From left to right are (first row) Marie Brown, Edith Henderson, Sarah Cox, and Helen Hunter Gresham; (second row) Nellie Thompson, Mildred Richardson, Alice League, and Lenora Riddle. (Courtesy of Brown and Pam Garrett.)

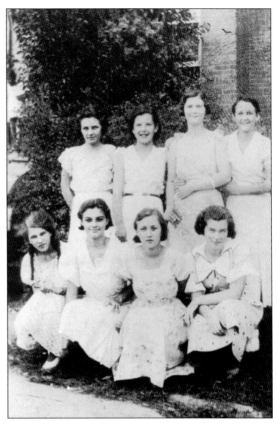

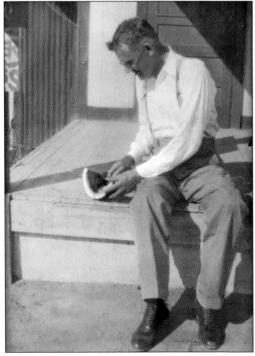

B.W. BURDETTE. Benjamin William Burdette, the founder and owner of the Burdette Hardware store, sits on the porch of his house adjacent to the Burdette Building enjoying a watermelon. B.W. is the son of Confederate veteran Benjamin Burdette and Eliza Smith. He married Ella Armstrong and had five children. (Courtesy of Butch and Diane Kirven.)

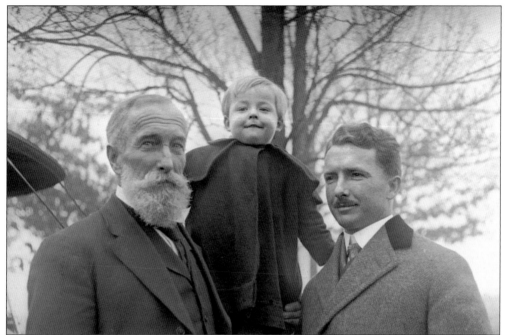

WILLIS FAMILY, 1910s. From left to right, Robert Henry Willis Sr., his grandson Bob Willis, and his son Lt. Col. Robert Henry Willis Jr. gather for a family portrait, likely taken by son Alfred Willis. The elder Robert was the superintendent of Simpsonville High School beginning in 1907 and was respected in the local education community. (Courtesy of the Willis Collection, Spartanburg County Public Libraries.)

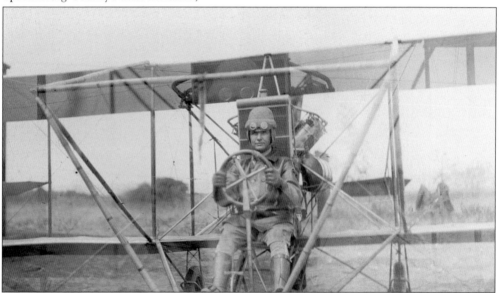

ROBERT HENRY WILLIS JR. After graduating at the top of his class from the Citadel, Simpsonville resident Lt. Col. Robert Henry Willis Jr. poses in his airplane. Willis received the War Department Military Aviators Certificate in 1913, and in February 1914 received an Expert Aviators Certificate from the Aero Club of America. (Courtesy of the Willis Collection, Spartanburg County Public Libraries.)

Toy Todd and Lake Taro. At right, Toy Taro Todd Sr. sits with his wife, Martha "Mattie" Gresham Todd, and two children. Toy and Mattie's son, Toy Taro Todd Jr., was the founder and namesake of the Lake Taro recreation site pictured below, which existed from 1932 until 1963. Toy Jr. constructed the site, along with Grady Mayfield, Jake Stewart, Bill Stewart, and Al White, on property leased from Monroe Fowler. The two-acre lake and surrounding site included a bathhouse, stoves, picnic sheds, a large dancing area, and an outdoor bowling alley. It closed in 1963 and was demolished in order to expand the Church of God campgrounds, located on Monroe Road to the north of Simpsonville. (Right, courtesy of Bill Gresham; below, courtesy of Brown and Pam Garrett.)

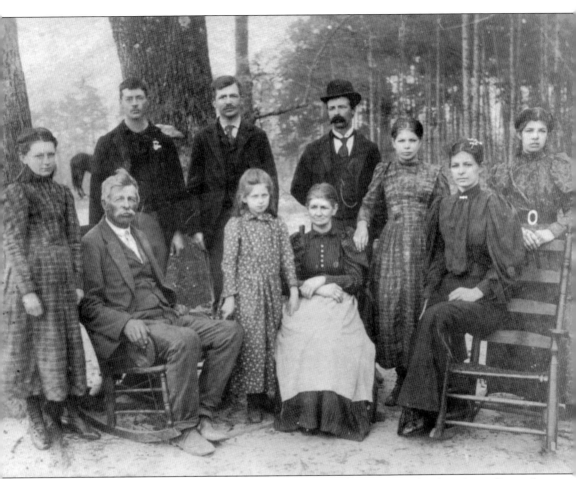

RICHARDSON FAMILY, C. 1900. George W. Richardson and Lou Cox Richardson (seated) pose for a family portrait with their children, including Dr. Lawrence Lafayette Richardson (center, with hat), Effie, Darlington, Clara, Nancy, Louisa, Maude, and George. George and Lou Richardson were influential in organizing the Unity Baptist Church to serve Simpsonville's southern edge. Dr. Richardson is notable for having served over 60 years as a physician in Simpsonville, for serving as the superintendent of Simpsonville schools, and for serving as mayor for over 30 years, from 1917 to 1958 (excluding the period 1923–1928). During his tenure as mayor, Dr. Richardson's most central belief was that liquor should not be allowed in Simpsonville, and he took special care to keep it out by requiring that all businesses have two doors; state law requires businesses selling liquor to have only one. (Courtesy of Caroline Richardson Mahaffey.)

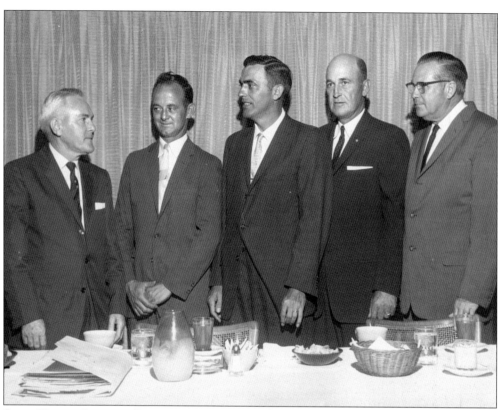

STEVE HIOTT. Simpsonville mayor Steven W. Hiott Jr. (center) stands with, from left to right, Mr. Verdin of the County Library Board, Mayor Clarence Barbrey of Mauldin, Mayor Ed Green of Fountain Inn, and Mayor Lloyd Hunt of Greer at a Greenville County Library event in 1960. Hiott served one term as mayor, from 1958 to 1963, and worked for the Farmers Bank. (Courtesy of the Greenville County Library System.)

RICHARD W. RILEY. Serving as Simpsonville's city attorney in the early 1960s, Richard "Dick" Riley was responsible for obtaining the charter that began the Simpsonville Chapter of Rotary International. After his time in Simpsonville, Riley went on to serve in the South Carolina General Assembly, then later as governor of the state and as the US secretary of education. (Courtesy of the Greenville County Library System.)

R.L. "Penny" Richardson. Mayor Robert Lee Richardson stands in front of the town's original train depot, demolished in the 1960s. Better known in the community as "Penny," Richardson lived from 1900 to 1987, and was mayor from 1963 to 1975. As mayor, Richardson oversaw the construction of a new train depot and a new school building to replace the old Simpsonville High School. (Courtesy of Pat Henderson.)

General Westmoreland with Major Austin. Spartanburg native Gen. William Westmoreland (far left), commander of US troops in Vietnam, stands with Robert Ashmore and Simpsonville residents Maj. William "Bill" Austin Jr and his wife, Myrtle. Maj. Austin was a prisoner of war in Vietnam from 1967 to 1973 and is a direct descendant of Simpsonville's early settlers. (Courtesy of the Greenville County Library System.)

RALPH HENDRICKS. As the owner of the Hendricks Building Supply company and later the mayor of Simpsonville, Ralph Hendricks left a mark on the city for several decades. In the late 1960s and early 1970s, Hendricks was responsible for the development of several Simpsonville neighborhoods, most notably Westwood and Poinsettia. He was elected to succeed Penny Richardson as mayor in 1975, serving for three terms ending in 1987. At the end of his term, Hendricks and his company were responsible for building an instant icon of the city—the clock tower located at the central intersection of Main and Curtis Streets. When a new building was constructed in 1997 to house the Simpsonville branch of the Greenville County Library, the branch was named for Hendricks in honor of his generous contributions to both the city and the library. (Courtesy of the Simpsonville Area Chamber of Commerce.)

THREE MAYORS, 1970s–1980s. From left to right, Ralph Hendricks, R.L. "Penny" Richardson, and Steve Hiott pose together in front of a banner advertising "A New Day" in Simpsonville. Collectively, the trio's tenures as mayor spanned a period of nearly 30 years. (Courtesy of Geneva Lawrence on behalf of the City of Simpsonville.)

JOSEPH "LANNY" MONTGOMERY III. Mayor Lanny Montgomery rides in the 1990 Christmas parade. Montgomery took office in 1987, following the 12-year tenure of Ralph Hendricks, and served one term ending in 1991. Among Montgomery's notable initiatives were the Clean-Up Days, expanding on a program started by Mayor Hendricks. (Courtesy of the Simpsonville Area Chamber of Commerce.)

PAMELA OSTEEN KING. Mayor Pam King, Simpsonville's first female mayor, serving from 1992 to 1995, stands at right. King moved to the area in 1981 and founded the Golden Strip Gymnastics Center, one of the most prominent gymnastics facilities in the state. As mayor, King focused on anti-litter efforts, continuing the Clean-Up Days and beginning the city's recycling program. (Courtesy of the Simpsonville Area Chamber of Commerce.)

CITIZEN OF THE YEAR. Gene Norris, the organizer of the Christmas in the Park event to help those in need, rides in the 1994 Christmas parade as the Citizen of the Year. The Simpsonville Area Chamber of Commerce bestows this honor on an area resident each year, and recipients are offered a spot in that year's parade. (Courtesy of the Simpsonville Area Chamber of Commerce.)

RICHARDSON AND BALCOME. From left to right, Jeff Richardson Jr., Wallace Balcome, and Edith Brown Balcome sit together at a chamber of commerce function in the 1980s. Richardson was the owner of the Jeff Richardson Company, a real estate agency started by his father. The Balcomes were successful farmers who donated a large amount of land to the Church of God for a children's home. (Courtesy of the Simpsonville Area Chamber of Commerce.)

DENNIS WALDROP. First elected to city council in 1992, Dennis Waldrop became the mayor of Simpsonville in 1995 upon the resignation of Pam King. Waldrop served as mayor for 16 years, with his most major accomplishments being the construction of a new senior and activity center and the creation of Heritage Park. (Courtesy of Dennis Waldrop.)

Seven

HISTORIC HOMES

As residents go about their daily lives throughout the city, they drive past them every day. It may be that friends or neighbors lived there, or maybe it was a favorite teacher from elementary school. Perhaps people just notice the beautiful architecture or the lot that has been empty for years. In any case, there are many vintage properties in the area that deserve to be noticed and remembered, even if they are not the polished jewel they once were.

Unfortunately, there are many historic homes that have been torn down and lost forever. For instance, the F. Morgan Todd home was built in 1906 and once stood on East Georgia Road. It had wide yellow-pine flooring upstairs and huge, beautiful mantles throughout. The grand homestead was razed in May 1947. There was also a large pre–Civil War home, which stood near the intersection of North Maple Street and West Georgia Road. The house had several prominent owners throughout its history, including the city's first postmaster and also the city's fourth mayor. Known as "the old Moore home" in its later years, the structure was torn down in 1984.

Luckily, there are many homes both within the city limits and on the outskirts that have been well preserved and maintained. The oldest examples include the Oakland plantation and Gilder, both built and established by some of the earliest settlers in the area. Noteworthy, too, are more modern homes such as the Howard property on East Curtis Street (beside the Springs assisted living center). The residence is currently undergoing restoration and expansion, while maintaining its original charm. Farther east on Curtis Street, just before the main entrance to the Poinsettia subdivision, is a lovely early 20th-century home built by the Chandler family and later sold to the Todds. Simpsonville is indeed enriched by these lovingly well-kept homes that will surely be appreciated for generations to come.

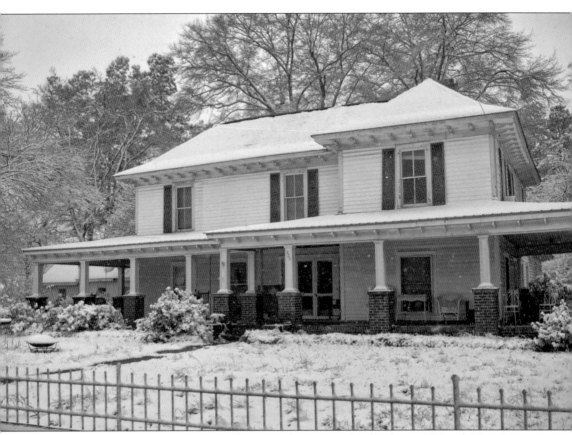

RICHARDSON HOME. This large, white home on the corner of Richardson and South Main Streets was built in 1904. One of Simpsonville's most prominent citizens, Dr. LL. Richardson, lived here with his second wife, Bessie Harrison Richardson, until his death in 1958. Dr. Richardson's great-granddaughter, Caroline Richardson Mahaffey, is now the owner of the property. In the early 20th century, teachers from the nearby Simpsonville School were allowed to board in the home. They lived among the Richardson family, ate meals with them, and were even taken on outings by Mrs. Richardson. On the adjacent corner, Dr. Richardson had a home constructed for his mother, which also still stands today. (Photograph by Christy Staton.)

HILLCREST HOME. This lovely home on South Main Street was built in 1912 and is now owned by Brown and Pam Garrett. The original owners were Pomeroy Brown and his wife, Florence, who were Brown's grandparents. Brown owned a grocery store in town until the mid-1940s. They raised their family in the home and eventually passed it along to their children. Marie Brown Garrett, mother of Brown (pictured above), lived in the residence along with her sister, Lois Abbott, until their deaths. The house underwent a remodel in 1999, but much of the original material was retained. The name "Hillcrest" comes from the name used for the land before anything was built there. (Above, courtesy of Brown and Pam Garrett; below, photograph by Christy Staton.)

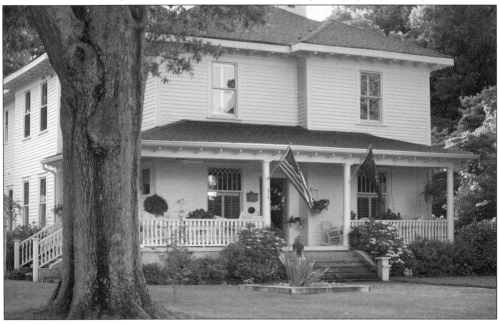

M.L. GRESHAM HOME. Built in the mid-1940s, this house at the intersection of North Maple and West College Streets was originally owned by Metz Lanford Gresham and his wife, Julia Maynard Gresham. Metz played football at Clemson University and served in the Army before becoming the third generation to own Gresham's Food Store. He also served on town council, as a chairman of trustees for the Simpsonville School District, was a scoutmaster, and retired from the Greenville County Sheriff's Office. The home remained in the Gresham/ Gault family until 2015, when it was purchased by another local business owner. (Photograph by Christy Staton.)

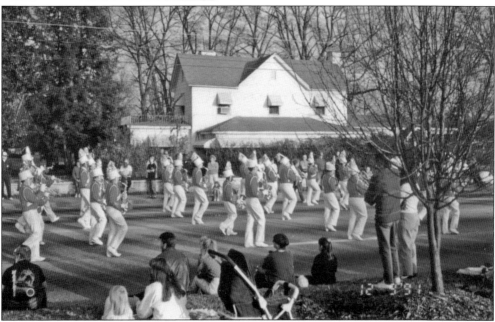

JONES HOME. This house no longer stands, but once sat at the corner of East Trade and Main Streets. It was owned by Paul Goodwin Jones and his wife, Essie Mae Howard Jones. Paul owned the Simpsonville location of his father's business, T.E. Jones and Sons furniture store. Essie Mae was the daughter of prominent Simpsonville doctor A.S. Howard and the granddaughter of Dr. Pliney League. The photograph shows the Hillcrest High School marching band in front of the residence during a Christmas parade. (Courtesy of the Simpsonville Area Chamber of Commerce.)

ARMSTRONG-TODD HOME. Around 1910, Jonathan Dial Armstrong Jr. and his wife, Mary, had this home built. Jonathan co-owned a popular grocery store in Simpsonville with his son-in-law, John W. Todd, whose family also lived in the home. Currently, the house is owned by Dollie Stutts Tuttle and is used for mixed purposes. It contains the headquarters for the women's ministry B Encouraged. (Photograph by Christy Staton.)

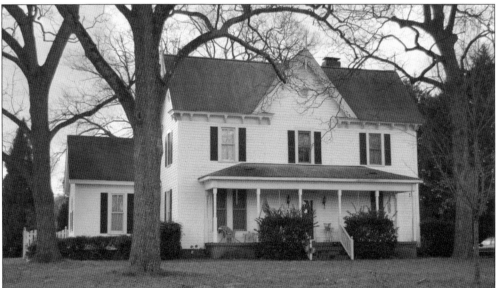

HEDGE STREET HOME. This residence at 122 Hedge Street is the oldest house that still stands in the city of Simpsonville. It was built around 1880 by Sidney J. Wilson, whose name is found on the charter application for the city. Wilson was also one of the founders of the Simpsonville First Baptist Church and the railroad depot manager for a time. The home has had many owners throughout the years. One disliked the residence facing Main Street, so he had it turned to face an alley behind the house that was lined with beautiful hedges. In more recent history, the home was owned by Mike and Kathy Fleming, proprietors of Fleming's Garage. (Photograph by Christy Staton.)

GREENE-LEWIS HOME. One of the most recognizable historic homes in downtown Simpsonville is the Greene-Lewis home, at the intersection of West Curtis and Maple Streets. The house was built in 1885 by George Hembree Greene and his wife, Leila Gresham Greene, daughter of W.P. and Caroline Jones Gresham. At one point, the home contained the first telephone switchboard used in the town. Since the Lewis family has taken possession, the home has undergone a few renovations, including the modernization of the kitchen and new front doors from a townhouse in New Jersey. Yet several features of the vintage residence remain, such as the outdoor swing hanging from planking cut from a cedar tree that was original to the property. (Photograph by Christy Staton.)

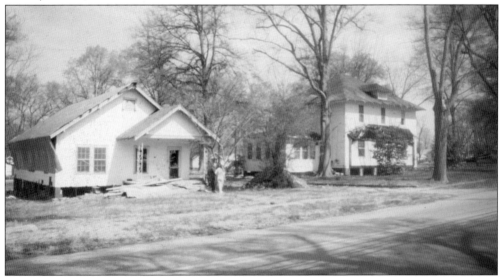

FORMER WEST CURTIS STREET HOME. In preparation for the ground-breaking for the Simpsonville Senior and Activity Center, a few mill area houses had to be demolished or moved, including the large one pictured here. Although the property owner is unidentified, it is believed this particular house was moved to Laurens and placed on private land for the family. (Courtesy of Geneva Lawrence on behalf of the City of Simpsonville.)

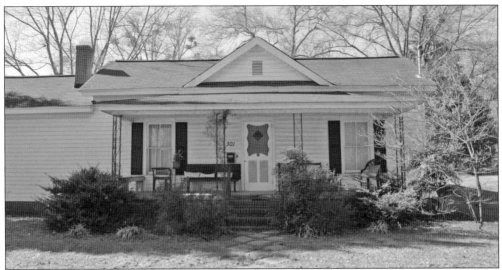

CHANDLER HOME. The construction date of this home is undocumented. However, records show that Ella Austin Jones owned it for many years prior to 1947. At that point, ownership passed to Mary Jones White and eventually to Mary Anne White Chandler. Chandler was a beloved teacher for several decades at Simpsonville Elementary School. She was born in this home, raised there, and returned with her husband, Wilton Maxwell Chandler, shortly after their marriage to help care for her father. (Photograph by Christy Staton.)

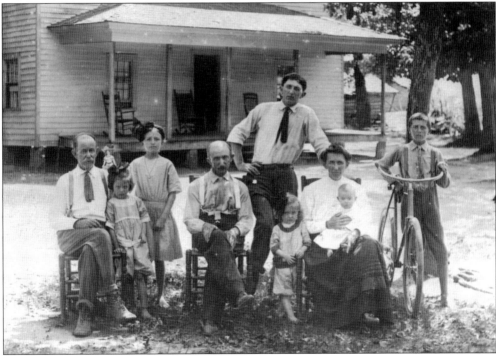

JONES FAMILY PORTRAIT. This portrait was taken at the Jones family home, or "old homeplace," in 1911. Family members pictured, from left to right, are Wiley Nelson Austin, Lois Jones Hunter, Mary Jones White, James Edmund Jones, Verner Jones, Shirley Jones, Ella Austin Jones, Edna Jones, and Roy Jones. (Courtesy of Mike Folk.)

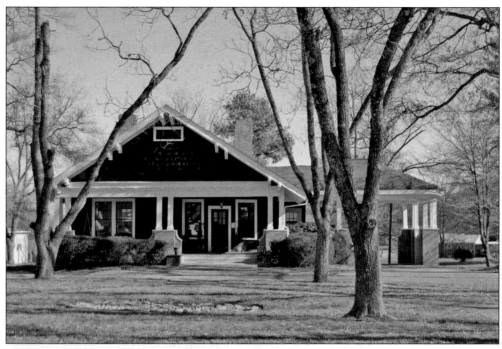

FORMER J.O. GRESHAM HOME. This house on Main Street sits beside the post office and originally belonged to John Oswall Gresham and his wife, Bessie Jane Welborn Gresham. John was the second mayor of Simpsonville. He was also the second generation to partner in ownership of Gresham's Food Store. Gresham was known as "Uncle John" to most of the population of Simpsonville. An original doorknocker still hangs on the front door today. The inscription reads "JO Gresham." The property is now used commercially as a realty company and a dance studio. (Both photographs by Christy Staton.)

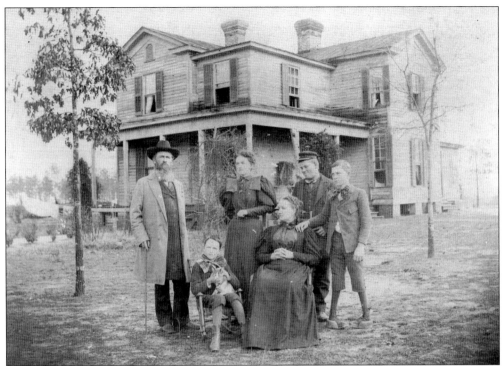

DR. PLINEY LEAGUE HOME. The former home of Dr. William Pliney League was built in 1896 and sits on South Pliney Circle. It originally sat directly on the old Laurens Road (Main Street), as seen above, but was moved about a block backwards and turned just prior to World War II. Dr. League fought alongside his brother, Thomas Riley League, in the 16th South Carolina Regiment during the Civil War, and then the pair attended medical school in Augusta, Georgia. Pictured above from left to right are Dr. Pliney League, his son Fred, his daughter Ola, his wife, Fannie, and his elder sons Gene and Herbert. Pictured below is the home as it stands today. (Above, collection of Eddie Howard, courtesy of Doug Mayfield; below, photograph by Christy Staton.)

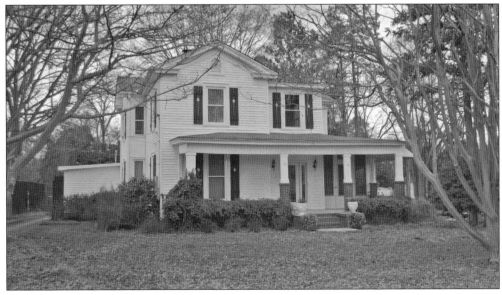

FORMER CHURCH STREET HOMES. When Simpsonville First Baptist Church needed to expand its parking and construct a larger sanctuary, it had a need for additional land. As a result, most of the lots along Church Street were purchased by the church, the existing homes demolished, and the lots cleared. These photographs were taken in 2007, just prior to the homes being razed. (Courtesy of Pat Henderson.)

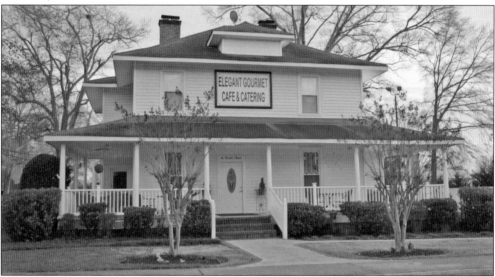

MUSIC COLLEGE DORMITORY. In 1911, the board of trustees of the Simpsonville School petitioned to have a music college brought to town. As a result, the home that sits at 111 Church Street was built as the dormitory for the new college on land donated by Florence Duane Hunter. It served as such only until 1918, when the music program was absorbed into the curriculum of the elementary and high school. At that time, Lawrence J. Vaughn and his wife, Pearl Sutherland Vaughn, bought the property. The home has remained in the possession of Vaughn family descendants ever since. Currently, the ground level of the home is the catering and restaurant establishment Elegant Gourmet. (Courtesy of Christy Staton.)

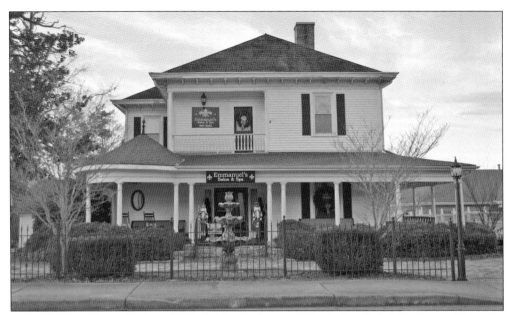

A.R. HUNTER HOME. Built in 1906, the former home of Dr. Arthur Ralph Hunter and his wife, Martha Cooke Hunter, sits at 201 East College Street. The house is a two-story Victorian with a gazebo and wraparound porch, and much of the intricate woodworking in the home, such as virgin pine columns and wainscotings, was carved by steam-powered machinery at the cabinet shop owned by Henry Goodwin, G.W. Goodwin, and David Mayfield. The Hunters raised four children in the home, and Dr. Hunter had his practice in a smaller dwelling on the property. Once both original owners passed away, Baldwin's Nursery was opened in the home and run by Frances Baldwin for many years. Since its closing, the house has hosted several businesses including a gift shop, florist, bed-and-breakfast, and salon. (Photograph by Christy Staton.)

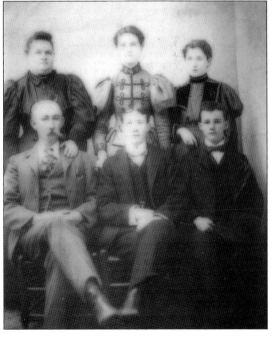

HUNTER FAMILY. This portrait shows the Hunter family. From left to right are (seated) Florence Duane Hunter (1859–1931), Arthur Ralph Hunter (1879–1946), and Arch L. Hunter (1882–1939); (standing) Alice Todd Hunter (1861–1936), Ethel Hunter (1881–1956), and Nannie Hunter (1884–1985). (Courtesy of Mike Folk.)

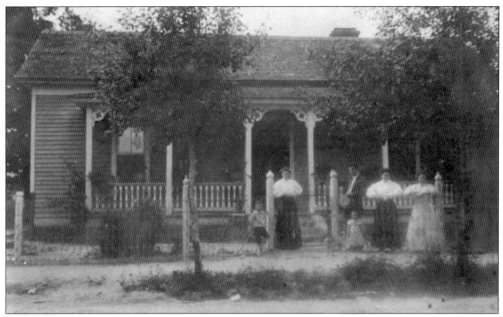

BURDETTE HOME. The former home of Benjamin William Burdette (1878–1965), original owner of Burdette Hardware, stands at the intersection of East Curtis and Hedge Streets. Not much is known about this home, but it is believed to be a late 19th-century frame house with late 20th-century alterations and additions. (Courtesy of Butch and Diane Kirven.)

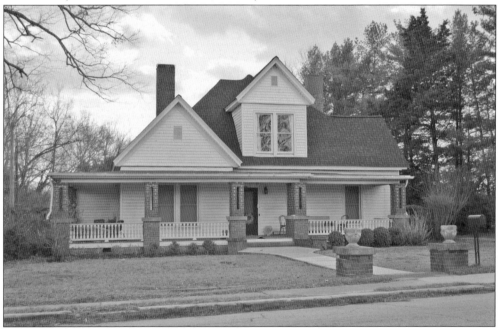

FOWLER-CHANDLER-TODD HOME. This home, which sits just across East Curtis Street from the entrance to the city park, has been occupied by several prominent residents of Simpsonville throughout its history. Residents include Dr. Wade D. Fowler and his second wife, Nannie Stewart Fowler, World War II veteran Furman M. Chandler and family, Ludella Abercrombie Todd (wife of first mayor), and descendants of the Todd family. (Courtesy of Christy Staton.)

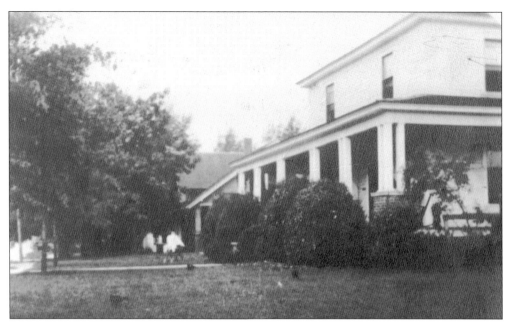

McKinney-Coker Home. No longer standing, this home was located on the corner lot of East Curtis and Academy Streets, across from the original library building. It was built by William Jefferson McKinney, whose family moved there in 1919 from their former home on Jonesville Road. McKinney and his wife, Rossie, raised six children here. Many years later, one of their daughters, Virgil, and her husband, Ed Coker, took possession of the home and raised their four children there as well. In about 1964, the house was sold to the First Baptist Church and was demolished in 1977. (Courtesy of Pat Henderson.)

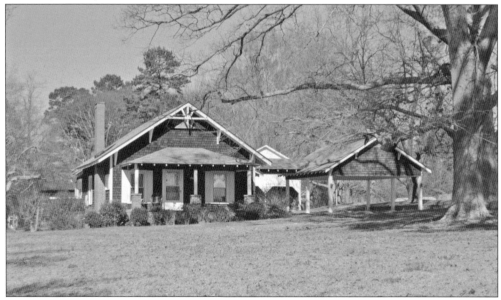

Knight-Boiter Home. This is one of the last remaining homes original to the Jonesville Road area. Since its construction, it has remained in possession of the same family and their descendants. Situated on a corner at the intersection of Scuffletown and Jonesville Roads, this house is easily recognizable and loved by many. (Photograph by Christy Staton.)

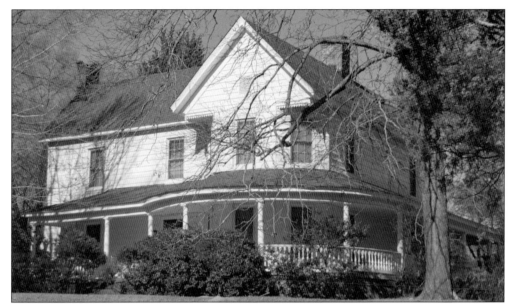

Howard Home. On the corner of East Curtis Street and Howard Drive sits the former home of Dr. Andrew S. Howard. It is a grand home with a large wraparound porch and several brick chimneys. Dr. Howard was a prominent physician who married Ola, the daughter of Dr. Pliney League. He was very involved in his church and the community, serving as a trustee of the Simpsonville School and active with the local Boy Scouts. Toward the end of his career, Dr. Howard ran his medical practice solely out of an office in his home. It remains in the Howard family. (Courtesy of Christy Staton.)

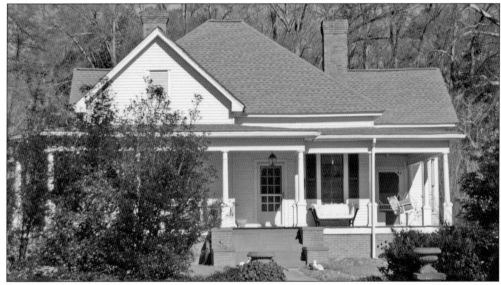

Bramlett Home. This house sits along West Georgia Road, between Bramlett Street and Jones Avenue. In 1906, it was constructed and occupied by R.D. Jones, a local merchant turned undertaker, and his family. In 1914, the home was sold to Decatur Lee Bramlett and his wife, Carrie Gresham Bramlett, who raised four children there. D.L. Bramlett became president of the Farmers Bank, a trustee for the Simpsonville High School for 10 years, and a member of the advisory board of the History of Greenville County. (Courtesy of Christy Staton.)

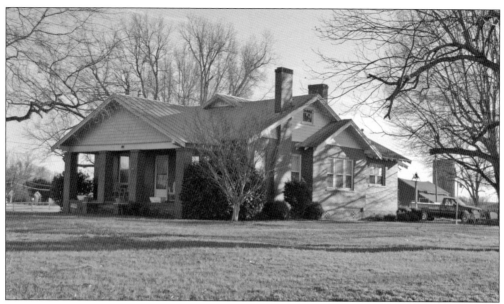

MARTIN HOME AND FARM. This was the home of Sheriff J.R. "Bob" Martin from the time of his birth until his death in 2011. He and his wife, Helen, raised two daughters there while also maintaining a dairy farm. The home and land once belonged to Martin's father, Edward Luther Martin Sr. As a memorial, the intersection of Fairview and Harrison Bridge Roads, where the home sits, was named for Sheriff Martin after his retirement. (Photograph by Christy Staton.)

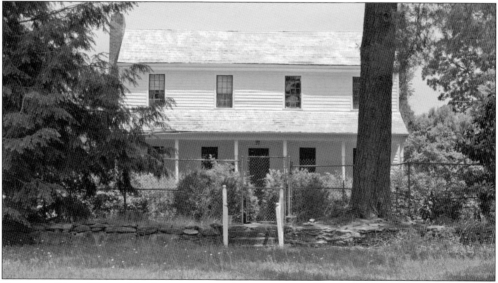

CURETON-HUFF HOME. This home sits on a large expanse of land near the intersection of West Georgia and Fork Shoals Roads. Also known as Valley Cove Farm, it was listed in the National Register of Historic Places in 1983. It is a two-story frame farmhouse built around 1820. The grounds include a carriage house, blacksmith shop, several barns, animal pens, garage, and family cemetery. The Cureton portion of the name comes from John Moon Cureton and his wife, Mary Adkins Dacus, who were the original owners of the house. The Huff portion comes from Pascal Dacus Huff and his wife, Jane Adelaide Sullivan, who was the granddaughter of the original owners. (Photograph by Christy Staton.)

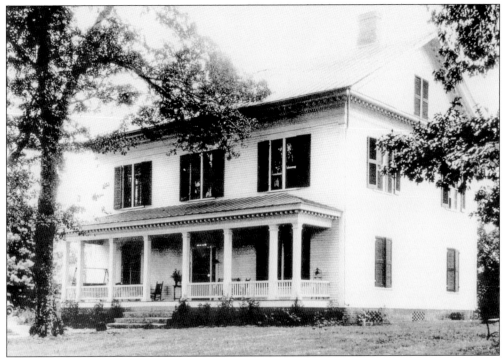

HARRISON HOME AND FAMILY CEMETERY. This home and cemetery were both established on a portion of 640 acres of lands granted to James Mason Harrison (1748–1815) as reward for his service in the Revolutionary War. It was most likely his grandson Dr. James Perry Harrison who had the three-story plantation house constructed in 1844. Sadly, the home burned just after completion, but was immediately rebuilt, and the family continued to live there for almost 100 years. Much of the original land, including the location of the Battle of the Great Cane Break, was sold to John Hopkins (nearby Hopkins Farm) in 1834. Dates on the graves in the Harrison Family Cemetery range from 1792 to 2005. (Above, collection of Carol Hightower Leake, courtesy of Steve Cox; below, photograph by Christy Staton.)

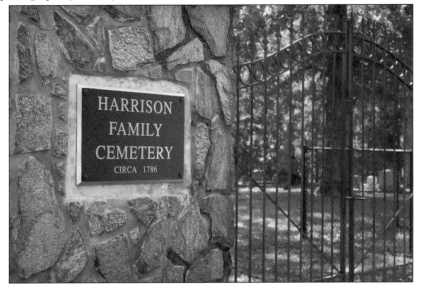

Eight

PUBLIC SAFETY AND SERVICES

The rapid development of Simpsonville over the past century has been due in large part to the excellent public resources that exist in the city—from safety to services including police, fire, medical, water, and sewer, as well as post offices and libraries.

The Simpsonville Police Department was founded in 1907, and consisted of two patrol officers for night and day. The department has seen 12 chiefs of police since 1928: Charlie Hamby, J.M. Godfrey, Toy McKinney, T. Roy McDougle, Nathan B. Morris, Daniel B. McCartney, Ray Brown, Larry R. Boyes, Randy Baldwin, Joseph Richardson, Charles Reece, and Keith Grounsell.

The Simpsonville Fire Department began in 1922 with a simple 30-gallon soda acid tank rolled around on two wheels. The city later got its first fire truck, which was parked in the local livery stable; a siren sounded when there was a fire. There have been only five fire chiefs for the town since its inception: Cecil Calvert, J. Dewitt Stenhouse, Dennis Pollard, Jess Major, and Wesley Williams.

As for other public services, the arrival of a water system in the 1950s is often regarded as the most important development in the city's history. The idea to install a water line extension from Greenville through Mauldin, Simpsonville, and Fountain Inn is often credited to George Webb, although it was Charlie Daniel (a US senator and founder of Daniel Construction) whose statement is the most widely known. Daniel said that a water line extension would make the three cities "the Golden Strip of Greenville County," creating the famous nickname for the area.

Although not utilities or safety measures, the library and post office are two pillars of the Simpsonville community that have always been by and for the public. The post office in particular is foundational to the community, as the town's namesake Peter Simpson was the postmaster upon his arrival in 1838. The library began in 1915 in the window of the T.E. Jones Furniture store, where Nannie Cox set up a simple bookshelf. Both of these institutions have evolved since these humble beginnings, becoming often underappreciated assets to the community.

HILLCREST MEMORIAL HOSPITAL. In 1963, the Greenville General Hospital System (now Greenville Health System) opened a 40-bed hospital near Hillcrest High School to serve residents of Mauldin, Simpsonville, and Fountain Inn. Several additions and new constructions—for one of which ground is being broken in this 1978 photograph—have greatly expanded the hospital in the half century since its opening. (Courtesy of the Greenville County Library System.)

ROUND HOUSE. Located in the middle of South Main Street, in front of Howard's Pharmacy, the Round House was the former Simpsonville city well and was later used as the police station for a number of years. Notice the Farmers Bank in the background, owned and operated by D.L. Bramlett. This is now the site of an Allstate office. (Courtesy of Butch Kirven.)

114

SIMPSONVILLE CITY HALL. In 1973, the building pictured here was constructed on East Curtis Street to house city hall and the police department. In 1987, after a fire destroyed the Hometown Food Store (formerly Winn-Dixie) on Northeast Main Street, the city purchased the property and again constructed a new city hall, leaving the police department to take over the entire older building. (Courtesy of Geneva Lawrence on behalf of the City of Simpsonville.)

SIMPSONVILLE CITY PARK. In 1957, the Greenville County School District sold the rear portion of its land on Academy Street to the City of Simpsonville. With the addition of lands from the Moore and Smith families, Simpsonville City Park was established and grew over the next several decades to include two baseball fields, tennis courts, basketball courts, a disc golf course, community building, community playground, and picnic shelters. (Courtesy of Geneva Lawrence on behalf of the City of Simpsonville.)

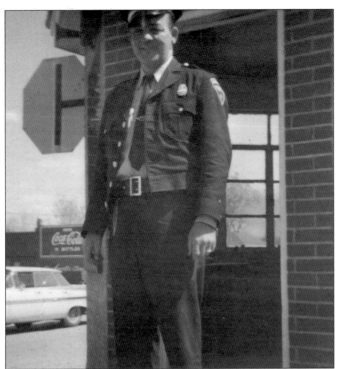

POLICE CHIEF MCKINNEY. Chief Toy J. McKinney stands in the doorway of the Round House, the small police station located in the middle of South Main Street. McKinney served as chief of police from 1962 to 1965, when a heart attack left him unable to resume his duties. He passed away the following year at the age of 43. (Collection of Annie Mae McKinney, courtesy of Doug Mayfield.)

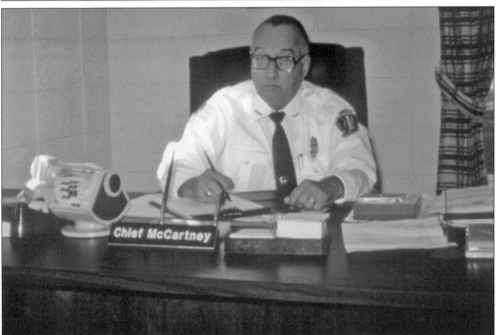

POLICE CHIEF MCCARTNEY. Daniel B. "Dan" McCartney served as Simpsonville's police chief from 1974 to 1982. McCartney was born in 1917 in the Panama Canal Zone, where his father worked as a chauffeur for the canal zone government. He died in 1985 and is buried in the Simpsonville City Cemetery along with his wife, Allie. (Courtesy of Geneva Lawrence on behalf of the City of Simpsonville.)

SHERIFF BOB MARTIN. Simpsonville resident James Robert "Bob" Martin served as the sheriff of Greenville County and was well known in the community. A graduate of Simpsonville High School and Clemson University, Martin served as a medic in the US Army during World War II, stationed in France. He then served as sheriff from 1957 to 1973, and is seen below with his many deputies. Sheriff Martin resided in his home at the corner of Fairview Road and Harrison Bridge Road for over 80 years, owning a vast amount of property on which he raised and raced horses, as well as raising cattle and Bermuda grass hay. Sheriff Martin passed away in 2011 and is buried at Fairview Presbyterian Church, where he was a lifelong member. (Both, courtesy of the Greenville County Library System.)

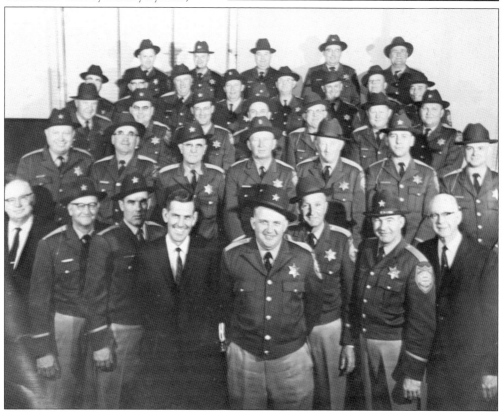

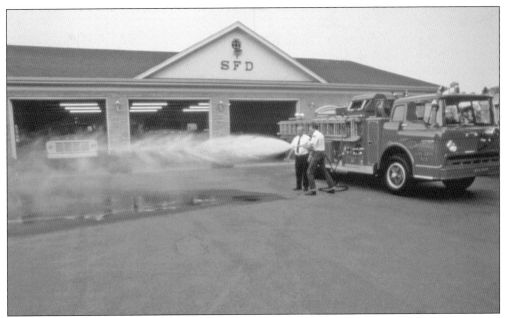

CURTIS STREET FIRE HEADQUARTERS. In 1968, a three-bay fire station was opened on West Curtis Street to become the headquarters of the Simpsonville Fire Department. Several additional stations have since opened around the city, and in 2012, the department renovated and began utilizing the former library (adjacent to the headquarters) as an administration building for the department. (Courtesy of Geneva Lawrence on behalf of the City of Simpsonville.)

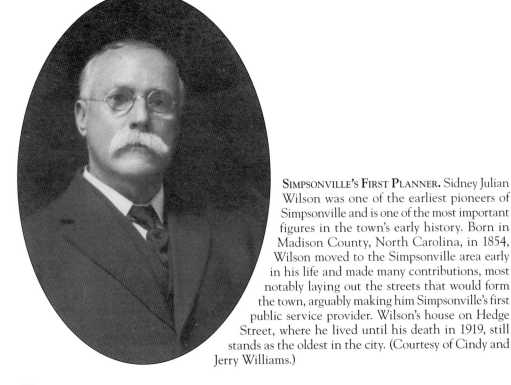

SIMPSONVILLE'S FIRST PLANNER. Sidney Julian Wilson was one of the earliest pioneers of Simpsonville and is one of the most important figures in the town's early history. Born in Madison County, North Carolina, in 1854, Wilson moved to the Simpsonville area early in his life and made many contributions, most notably laying out the streets that would form the town, arguably making him Simpsonville's first public service provider. Wilson's house on Hedge Street, where he lived until his death in 1919, still stands as the oldest in the city. (Courtesy of Cindy and Jerry Williams.)

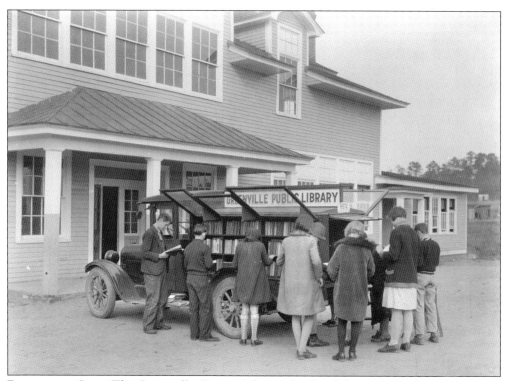

BOOKMOBILE STOP. The Greenville County Library's bookmobile serves local residents at an unidentified Simpsonville location. From 1926 to 1940, when the Simpsonville library was housed on the second floor of Simpsonville City Hall on West Curtis Street, the bookmobile served the community with a rotating selection of books every week. (Courtesy of the Greenville County Library System.)

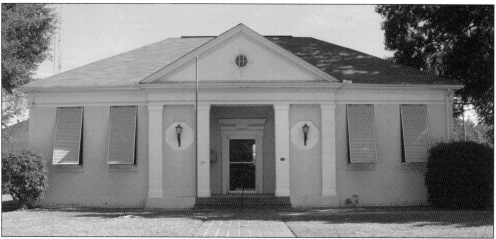

SIMPSONVILLE LIBRARY. The first freestanding library in Simpsonville, located at the corner of Academy and Curtis Streets, was constructed in 1940. It was well known as the common city voting location, and was in use until the Hendricks Library was built in 1997. The 1940 building is of brick construction, but was covered in white stucco and given green shutters during a renovation in 1968. It has since been restored to its original appearance by the fire department. (Photograph by Mike Burton.)

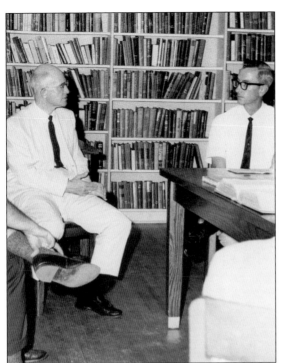

LIBRARY RENOVATION, 1968.
Greenville County librarian Charles Stow and Simpsonville Jaycees president Charles McCombs discuss renovations to the Simpsonville Library in 1968. The library renovation was sponsored by the Jaycees and led by McCombs, who also organized the Simpsonville Friends of the Library in 1968 and became its first president. (Courtesy of the Greenville County Library.)

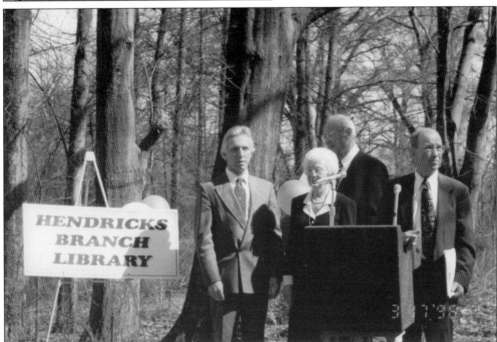

SIMPSONVILLE LIBRARY GROUND BREAKING, 1995. Addressing the needs of the developing community, the Greenville County Library System chose its Simpsonville branch as the next to be replaced in 1995. Simpsonville citizens helped generate over $300,000 for the project, and former mayor Ralph Hendricks and his wife, Marion, donated the land for the building. Accordingly, the branch was named in their honor. (Courtesy of the Simpsonville Area Chamber of Commerce.)

Nine

RECENT HISTORY

There are certain phases in the development of every city that shape its overall identity. The most recent phase in Simpsonville's long history is the one with perhaps the most development and change yet, arguably triggered by the death of longtime mayor Dr. L.L. Richardson in 1958 and the beginning of unparalleled growth spearheaded by Ralph Hendricks.

In 1956, by which time the cotton mill had been the biggest employer in Simpsonville for several decades, the company known as Cryovac announced the opening of a new factory near downtown Simpsonville. The front page of the new local newspaper read "Welcome, Cryovac!" as the community rejoiced, knowing that new jobs would bring new life into the area. One by one, new communities began to develop outward from downtown Simpsonville, with many being directed by the Hendricks Building Supply company led by Ralph Hendricks. The Poinsettia community first began to take shape on the former property of S.T. Moore, and other landowners such as the Richardson and Hughes families followed suit in selling off their vast properties for development. The Westwood community, on the western side of Simpsonville, was the largest of these developments and for several years was the largest subdivision in the state.

In the years that followed, communities have continued to develop as industry and retail multiply accordingly—most notably in the commercial corridor of Fairview Road. The sense of community pride in the newly developed neighborhoods has brought about festivals and cultural events, including the Labor Day Festival and Freedom Weekend Aloft, as well as the transformation of the former elementary school into an arts and cultural center. As the 21st century marches on, and institutions such as these continue to evolve, a new phase of the community is beginning to take shape—with Simpsonville as a larger and stronger city than ever before.

CRYOVAC PLANT. In 1955, after several years of searching for a suitable location, a division of the W.R. Grace Company known as Cryovac opened its doors on Maple Street in Simpsonville with a ceremony that included Gov. James Byrnes. The company was the first of many that began to open in the area, and drew many employees away from the mill. (Courtesy of the Greenville County Library System.)

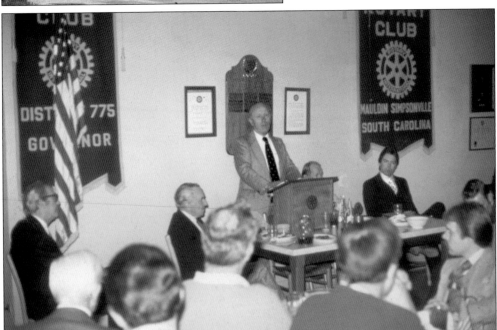

SIMPSONVILLE ROTARY CLUB. In a ceremony on October 5, 1961, Simpsonville city attorney (and later South Carolina governor) Richard W. Riley was presented the charter for the Simpsonville-Mauldin Rotary Club, also known as Rotary International District 7750. Rotarian Ralph Hendricks secured a lease for a vacant store building on Northeast Main Street in January 1962, establishing the present day Rotary Hall. (Courtesy of Geneva Lawrence on behalf of the City of Simpsonville.)

GIVENS YOUTH CENTER. As part of the community-wide cleanup day under the direction of Mayor Ralph Hendricks, a crew picks up litter off of West Georgia Road near the Givens Youth Correctional Center. This minimum-security facility for nonviolent offenders, located off Blakely Road, opened in 1969 and closed in 2001. (Courtesy of Geneva Lawrence on behalf of the City of Simpsonville.)

INGLES SHOPPING CENTER CLEANUP. The Ingles grocery store plaza, located on West Georgia Road just east of Highway 276, is cleaned up by a group of volunteers on one of the community-wide Clean-Up Days. The shopping center, which included the Ingles store, other businesses, and a restaurant known as Soup and Salad, was constructed for the ease of shoppers in the new neighborhoods west of Highway 276. (Courtesy of Geneva Lawrence on behalf of the City of Simpsonville.)

CLOCK TOWER. In 1986, nearing the end of his final term as mayor, Ralph Hendricks and his company broke ground on a new icon for the center of downtown Simpsonville—a large clock tower. Reconfiguring the layout of the South Main Street area, adding sidewalks, and shifting the path of the road, the clock tower's construction aimed to redefine the downtown area to provide for a more vibrant community. The clock tower was completed in 1987, and it has quickly become iconic and representative of the city of Simpsonville. (Both, courtesy of the Simpsonville Area Chamber of Commerce.)

LABOR DAY FESTIVAL. Beginning in 1974, the City of Simpsonville sponsored an annual Labor Day Festival held at the Simpsonville City Park. As one of only a few Labor Day events in the area, the festival attracted massive crowds and high-profile guests each year. Eventually, the festival relocated to Simpsonville's Main Street, and it ended in 2014. (Courtesy of Geneva Lawrence on behalf of the City of Simpsonville.)

LABOR DAY CAR SHOW. Some of the annual attractions of the Labor Day Festival were the automobile show, arts and crafts vendors, and in some years, a 5K race. The automobile show displayed cars owned by several local residents as well as others from around the country. (Courtesy of the Simpsonville Area Chamber of Commerce.)

GEORGE BUSH CAMPAIGN VISIT. When Texas governor George W. Bush was campaigning for the presidency in 1999, he made a stop at the Simpsonville Labor Day Festival. The visit drew some of the largest crowds in the festival's history, and put both the festival and Simpsonville in the national spotlight during a pivotal period for Bush's campaign. Incidentally, the Bush family has several connections to the area, with First Lady Barbara Pierce Bush's stepmother, Willa, being an Associated Press reporter from Greenville. When Willa married Barbara's father, Melvin Pierce, in Greenville in 1952, the wedding brought future presidents George H.W. Bush and George W. Bush to the area. (Both, courtesy of the Simpsonville Area Chamber of Commerce.)

FREEDOM WEEKEND ALOFT. In July 1981, a hot-air balloon festival with accompanying entertainment was held for the first time at Donaldson Center in lower Greenville County, attracting thousands of visitors. The festival relocated to Anderson County in 1999, then to Simpsonville's newly opened Heritage Park in 2007, where it was held on Memorial Day weekend for eight years. (Photograph by Christy Staton.)

SHERIFF MARTIN'S BARN. In the late 1990s, property owners along Fairview Road and Grandview Drive began selling their land to make way for new businesses. The horse barn of Sheriff J.R. Martin at the corner of Fairview and Harrison Bridge Roads, pictured here, was demolished in order to make way for a Spinx gas station and Bi-Lo grocery store. (Courtesy of Doug Mayfield.)

DISCOVER THOUSANDS OF LOCAL HISTORY BOOKS FEATURING MILLIONS OF VINTAGE IMAGES

Arcadia Publishing, the leading local history publisher in the United States, is committed to making history accessible and meaningful through publishing books that celebrate and preserve the heritage of America's people and places.

Find more books like this at
www.arcadiapublishing.com

Search for your hometown history, your old stomping grounds, and even your favorite sports team.